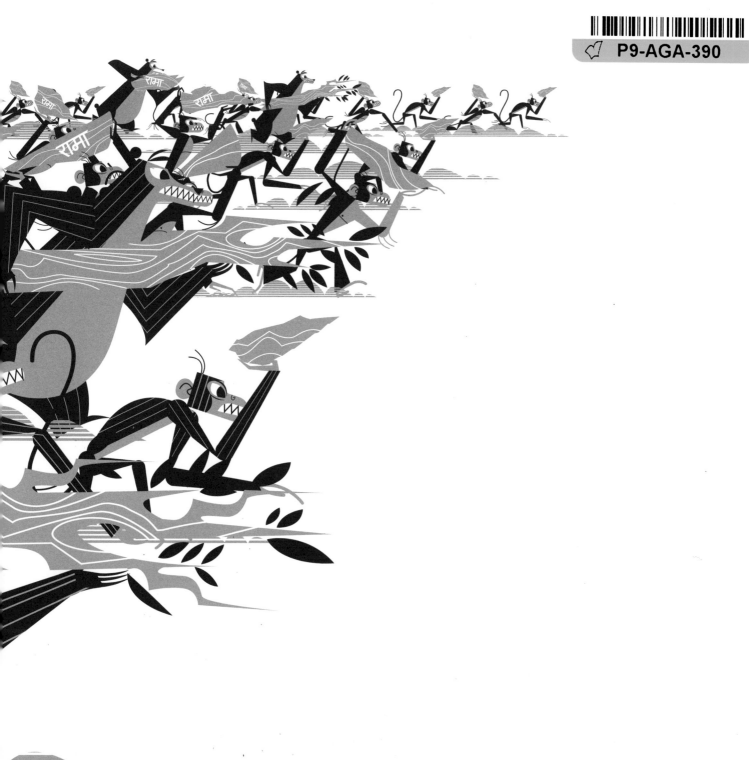

Valmiki—poet, sage, and father of
Indian verse—revealed the *Ramayana* to the world.

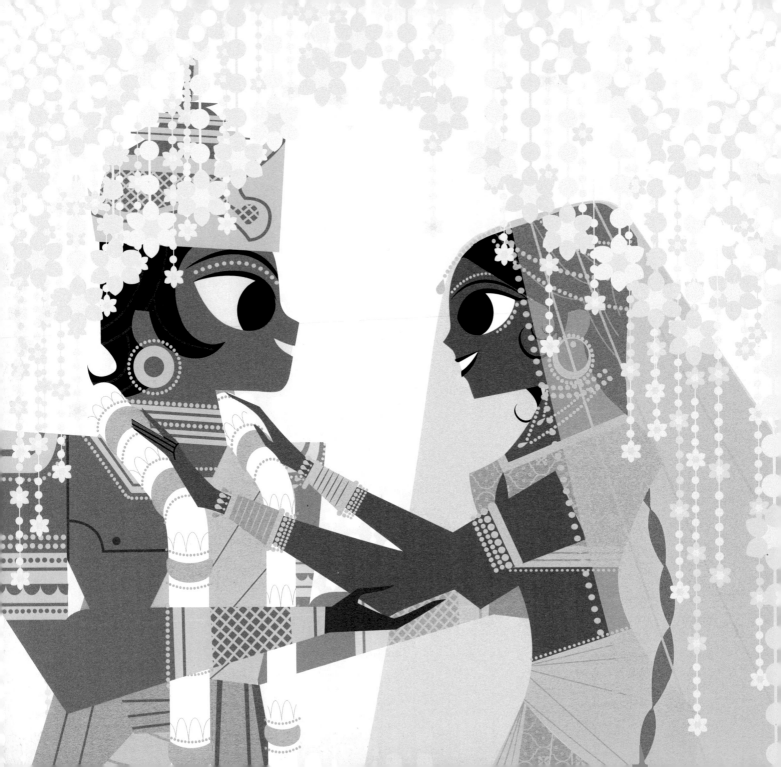

रामायण
RAMAYANA
DIVINE LOOPHOLE

✿

WRITTEN & ILLUSTRATED BY
Sanjay Patel

CHRONICLE BOOKS
SAN FRANCISCO

Library of Congress Cataloging-in-Publication
Data is available

ISBN: 978-0-8118-7107-5

Manufactured in China

Design by Sanjay Patel
Production Design by Chiraag Bhakta

20 19 18 17 16 15 14 13 12

Chronicle Books LLC
680 Second Street
San Francisco, CA 94107
www.chroniclebooks.com

MIX
Paper from
responsible sources
FSC® C104723
FSC
www.fsc.org

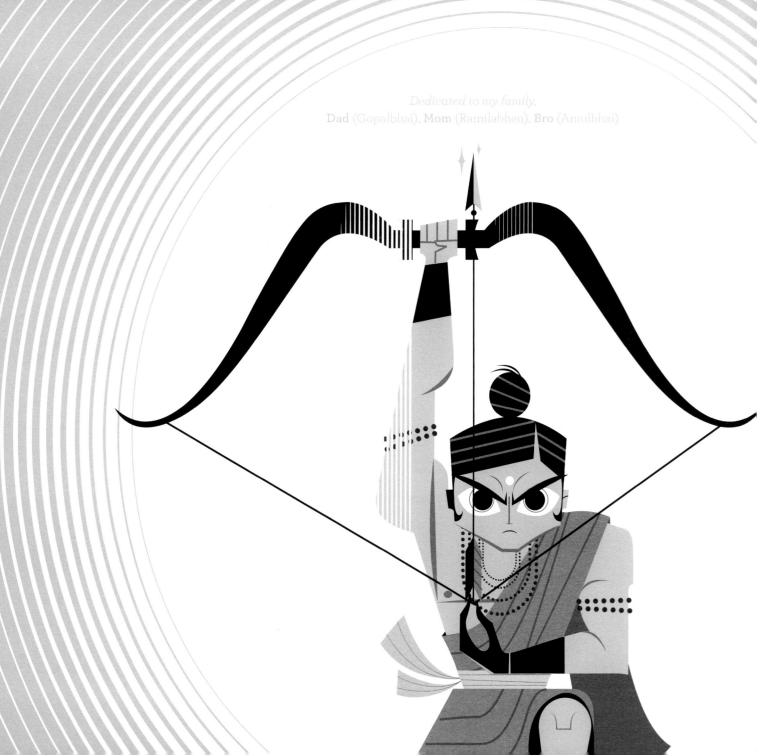

EPIC MYTHOLOGY WITHOUT ALL THE PAPER CUTS

I LOVE BOOKS, but I hate reading them.

Books put me to sleep. I can't even read a comic book without getting distracted by the cool artwork. As bad as I am about reading, I'm even worse with writing.

Despite this fact, I decided I was going to write my own book. I illustrated it and composed it, and it actually got published as *The Little Book of Hindu Deities*. And believe it or not, people liked it. I was so inspired by the experience that I decided to make a second book. I tossed around a lot of ideas, but once I picked up on the *Ramayana*, all other potential book proposals hit the back burner. I was hooked on this epic Indian tale.

I'm certain that, for most people, "Ramayana" (RHA-mah-YAH-nah) is just an unpronounceable word. But for me, the *Ramayana* is part of my cultural identity, though until recently I wouldn't have been able to explain what it meant if someone had asked. The world of the *Ramayana* was ingrained in me as a kid through the details of living with Hindu parents. For instance, every time I sneezed, my mom or dad would say, "Sita Rama,"—I had no idea what the phrase meant. Just like I had no idea why we had a framed illustration of a giant monkey carrying a mountain. Or why my dad made me count mala beads while chanting Rama, Rama, Rama. Eventually, as I started researching Hindu mythology for my first book, I began to scratch the surface of the Ramayana. But the story didn't really come alive for me until I picked up a book and read the entire saga.

I discovered a wonderful English-language adaptation of the *Ramayana* by the esteemed author Ashok K. Banker. His retelling weighed in at roughly three thousand pages, and it took me the better part of a year to read. As I read, the mythology sprang to life with full force, in all its wisdom, and I could feel my life being changed. For the first time, I began to see and understand the characters Rama and Sita as my parents did. I began to understand why it would be considered auspicious to speak their names, or why Hanuman's devotion to Prince Rama—epitomized by the extraordinary feat of moving a literal mountain of medicine—would be worthy of worship. It all began to make sense as I discovered a story that is the bedrock of Hindu and Indian culture.

The *Ramayana's* characters and legends have been deified and worshipped throughout India and much of Southeast Asia as well. The enduring story is revered in Thailand as the *Reamker*, performed as well as in Burma, Laos, and Malaysia. The Ramayana has crossed cultures and eras and shows no sign of dying, as its conflicts and themes are as relevant and constant as the human spirit.

The more I began to understand the *Ramayana*, the more inspired I felt to carry on the tradition of retelling the tale by creating an illustrated version. Since most people aren't inclined to sit through a thousand-page-long adaptation, I relied on graphic storytelling to capture attention and imagination. With this same spirit in mind, I wrote a much shorter and surmised version of the mythology. So if you're familiar with the *Ramayana*, chances are some anecdotes and details may be missing or reimagined in this version. My aim isn't to butcher this great mythology, but simply to share it with people in a casual and entertaining way. If I've done my job right, this book will serve as a vivid introduction to a much fuller version of the story. At the very least, it will help people understand why Hindus honor a blue warrior and a flying monkey holding a mountain.

Jaya Hanuman, jaya Rama (Victory to Hanuman, victory to Rama.)

Sanjay Patel
Oakland, CA

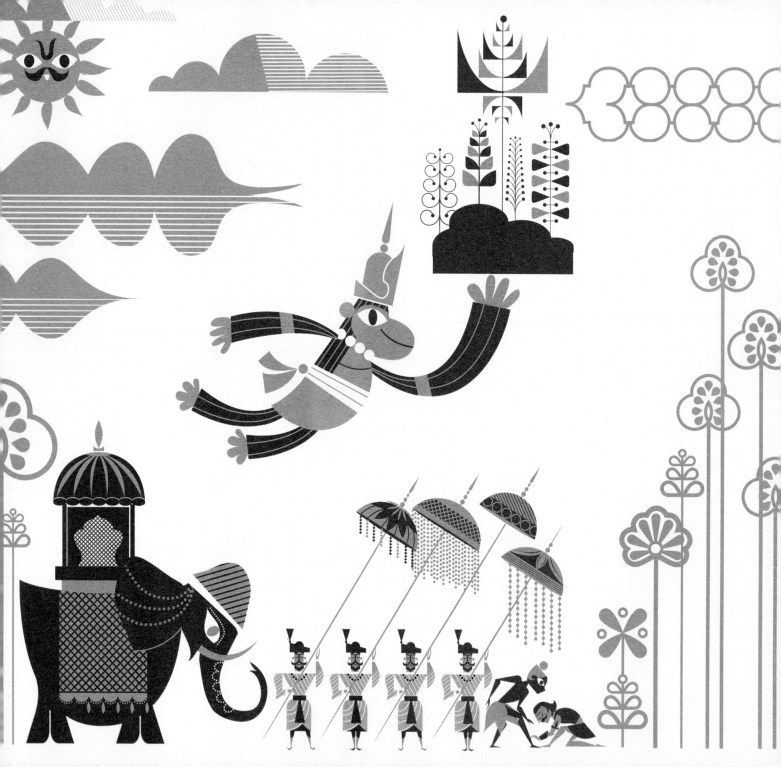

TABLE OF CONTENTS

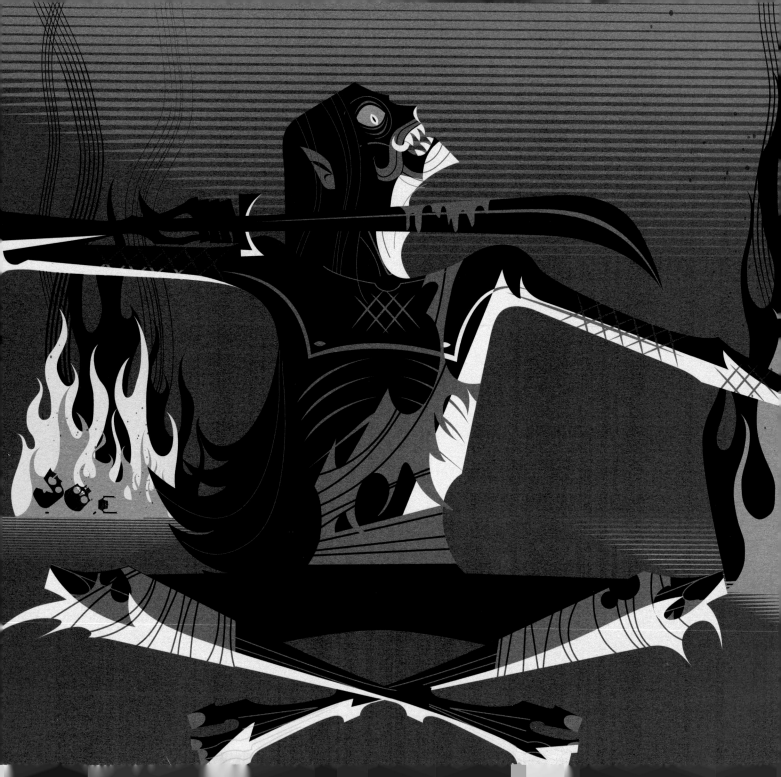

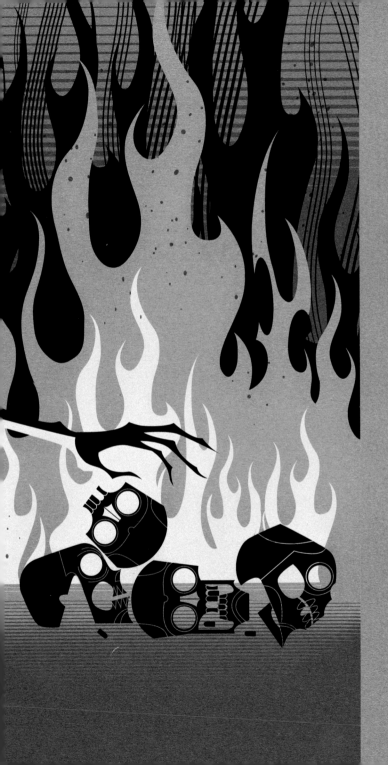

DESPERATE DEMON

S INCE THIS IS an epic story, let's start with the most scandalous of characters: the bad guy. This is no ordinary bad guy; we're talking about a ten-headed demon with bad teeth!

Scary as he looks, this demon didn't start out evil. He was actually a brilliant scholar (though even then, he still had ten heads), who meditated for thousands of years just to ask the gods for a wish. First, he fasted for five hundred years living only on the moisture in the air. Later, he stood on one toe and was exposed to the elements for another nine hundred years, never shifting a muscle even during winds and rain. To cap it off, he repeated the holy aum mantra for two thousand years without pause. He meditated for so long that he started to lose his mind, literally. The scholar decided to chop off his ten heads as an offering to the gods, one for every thousand years he waited. After sacrificing nine heads over nine thousand years, the scholar raised his sword to his last head and was set to end his life

COSMIC
BULLY

AS THE SCHOLAR'S sword descended,
the creator god Brahma appeared, willing
to hear his wish. The scholar was smart,
but not terribly imaginative, so he asked
for what many men wish for: to be the
most powerful creature in the universe.
Luckily, this was beyond what even the
god could grant, so the scholar asked
instead never to be defeated by any god
or demon. In what was perhaps one of the
bigger cosmic blunders of all time,
the honorable Brahma granted this wish.
The scholar transformed instantly into a
new kind of ultimate demon, growing
a row of fierce new heads and arms in
which he wielded terrible weapons. He
was large and in charge—a walking one-
man army.

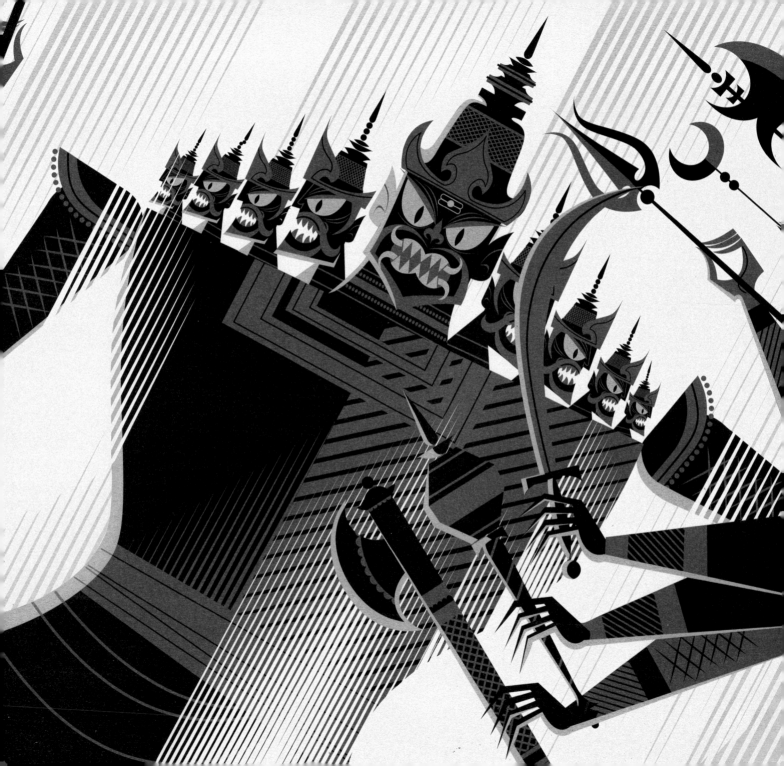

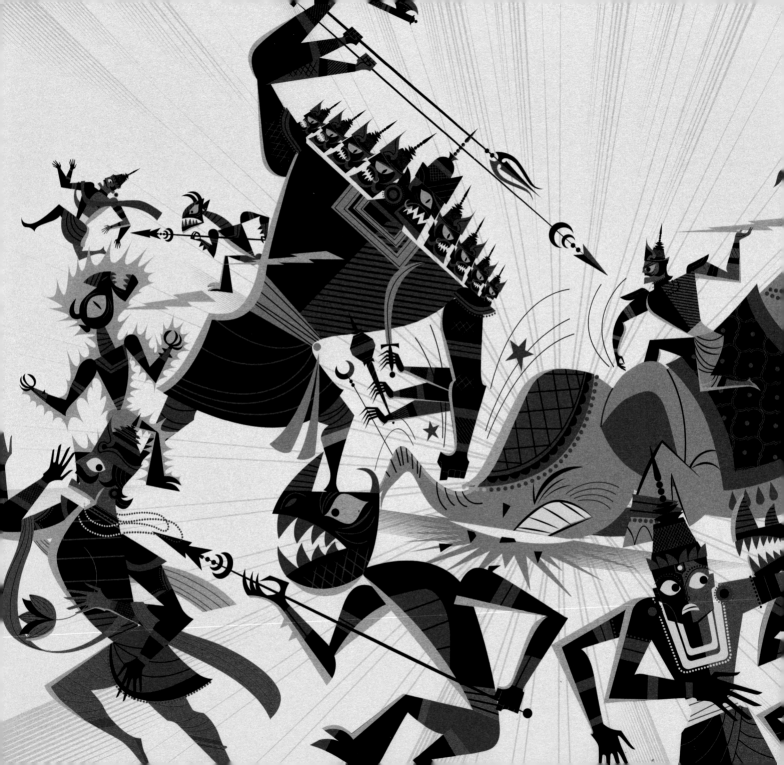

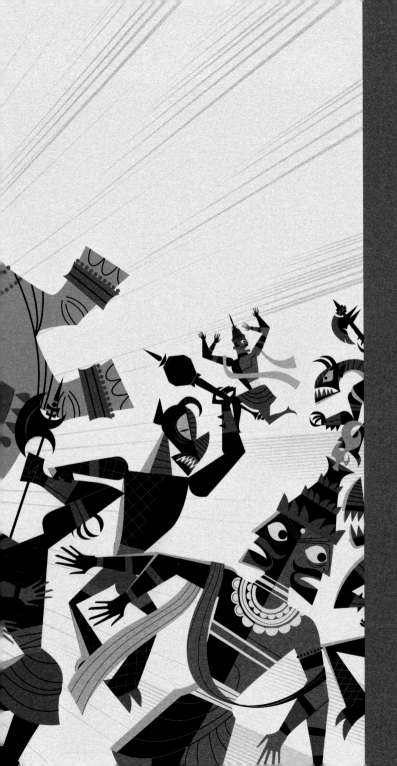

HOSTILE TAKEOVER

THE SCHOLAR-TURNED-DEMON'S appetite for power held no limits, and to prove he was truly the ruler of the gods, he decided to invade the realm of Swarga Loka, which is kind of like a heavenly waiting room for near-enlightened souls. Wielding tremendous power, he tore open a portal that reached down to the lowest level of hell, unleashing a race of demons known as rakshasas.

United with his demon army, he drove the gods out of their celestial abode and dethroned Indra, the ruler of heaven. The demon king was known from then on as Ravana, which means "the one that makes the universe scream."

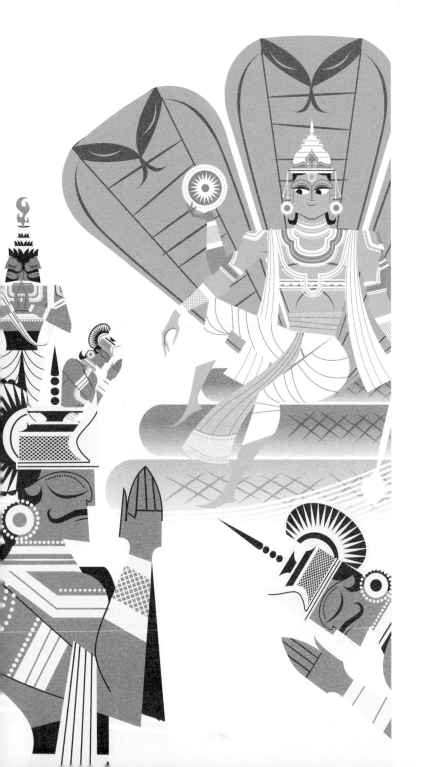

VISHNU'S LOOPHOLE

AT THIS POINT, the gods were in deep trouble with demons running amok over every corner of their world. They had no choice but to pay a visit to Vishnu, the god of preservation and general cosmic referee. The blue god of justice calmed everyone down and quickly pointed out that Ravana's plan had a divine loophole: Ravana only asked never to be defeated by a god or a demon—he was still vulnerable to humans and animals. Suddenly, there seemed to be hope. Vishnu then gathered the gods together and revealed a secret: He would reincarnate himself on Earth as a human to rid the world of Ravana. His avatar would be known as Rama, the blue warrior.

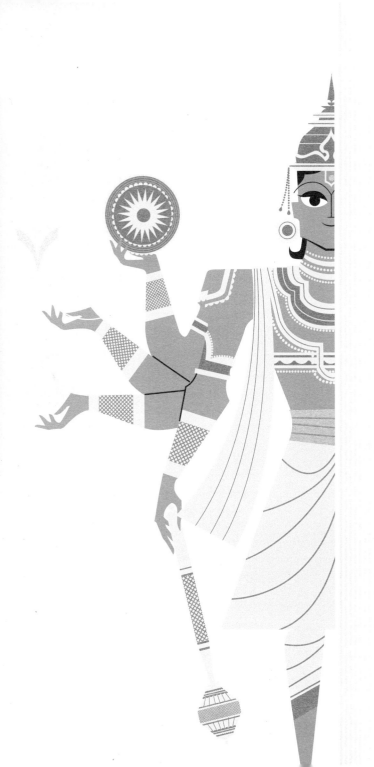
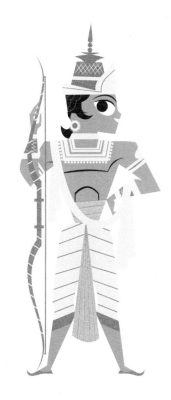

BLUE BOY

NOT MUCH LATER, as fate would have it, a special prince was born in the capital city of Ayodhya, just as Vishnu predicted. The young prince stood out from his three stepbrothers, Bharata, Shatrughna, and Lakshman, because his skin was blue from head to toe. His mother thought he resembled a god, but nobody, including the baby Rama, could have guessed that he was the avatar of Vishnu.

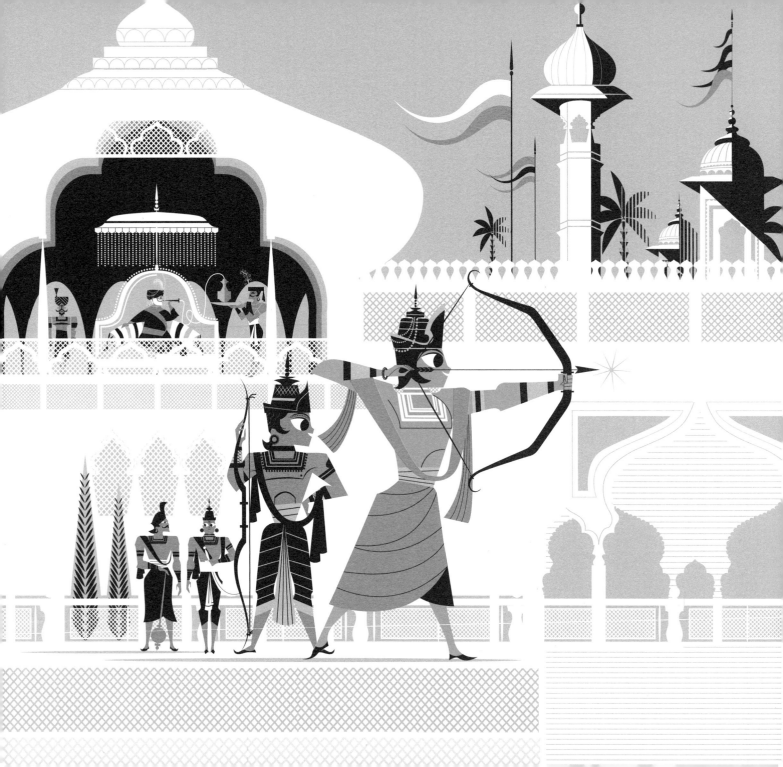

THE KING'S OWN adviser was put in change of educating and training the young princes. He guided them through their studies of Vedic knowledge, laws, and science.

As the princes grew up, they bonded over their different interests. Bharata and Shatrughna shared a love of sport and competition, whereas Rama and Lakshman loved nature and animals. As descendants of the warrior clan, all four princes were masters in the arts of war. But among the four princes, Rama proved himself to be a serene and compassionate leader and quickly became the apple of the king's eye.

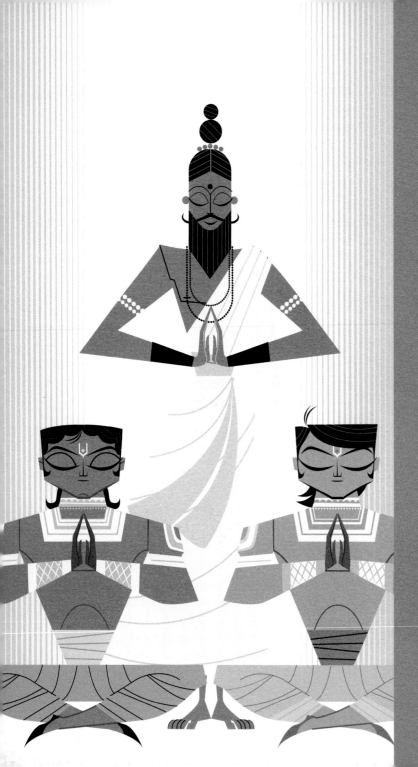

DEEDS OF RAMA

RAMA AND LAKSHMAN were insepa-rable. As they grew toward adulthood they were both recruited by an old sage, a brahmarshi named Vishvamitra, who could see into the past and future and predicted a special mission for the duo. The rishi (a high level of brahmarshi, or sage) wasted no time and began training his young recruits on how to harness the dev astras (weapons of the gods). He also taught them divine mantras and asanas that gave the young warriors profound strength and mental focus.

One day during their training, they visited Vishvamitra's ashram only to find that it was plagued by a demon named Tataka. The rishi explained that due to his vow of nonviolence he could not take up arms against the demon. Instinctively, Rama drew back his bow and the disre-spectful demon was soon vanquished.

As Vishvamitra performed last rites for the slain demon, he explained that Rama's action that day would have ramifi-cations in the future and cautioned him to always be mindful of his duty.

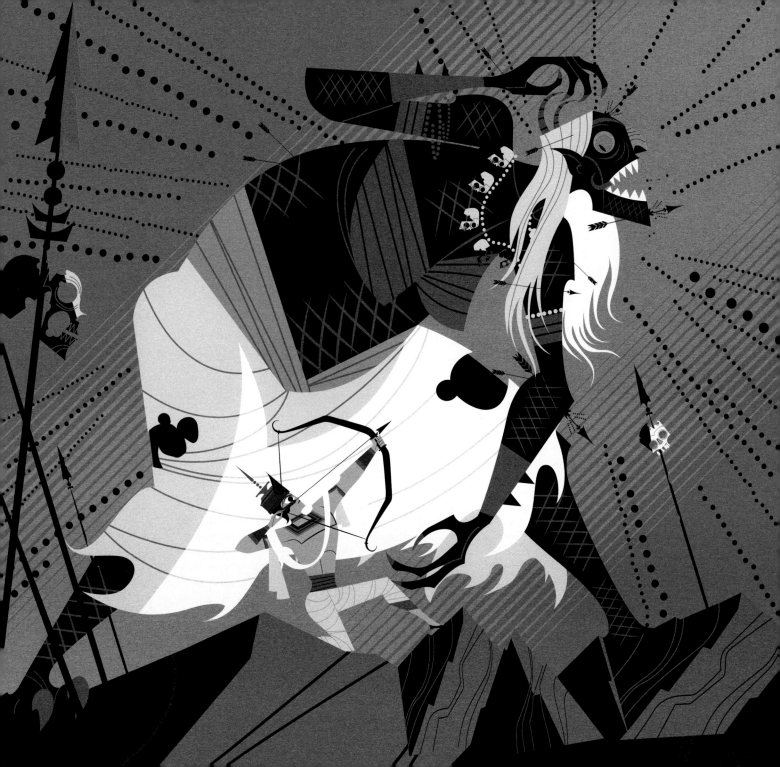

BREAK A BOW, TIE THE KNOT

BEFORE RETURNING HIS two pupils to their kingdom, the rishi had another vision, which led him to travel with the princes to the neighboring kingdom where an auspicious test was being conducted. The challenge was to lift the bow of Shiva, a feat that only a god could accomplish.

After hundreds of noble warriors tried and failed, Vishvamitra politely asked Rama to try. In a single motion, the blue prince placed his hand on the bow and lifted it high over his head. He quickly strung the bow, but as he pulled back it snapped and broke into pieces. Luckily, this accident was considered a miracle and was cause for a great celebration, as whoever was able to lift the bow would also win the hand of Princess Sita (who was actually an avatara of the goddess Lakshmi).

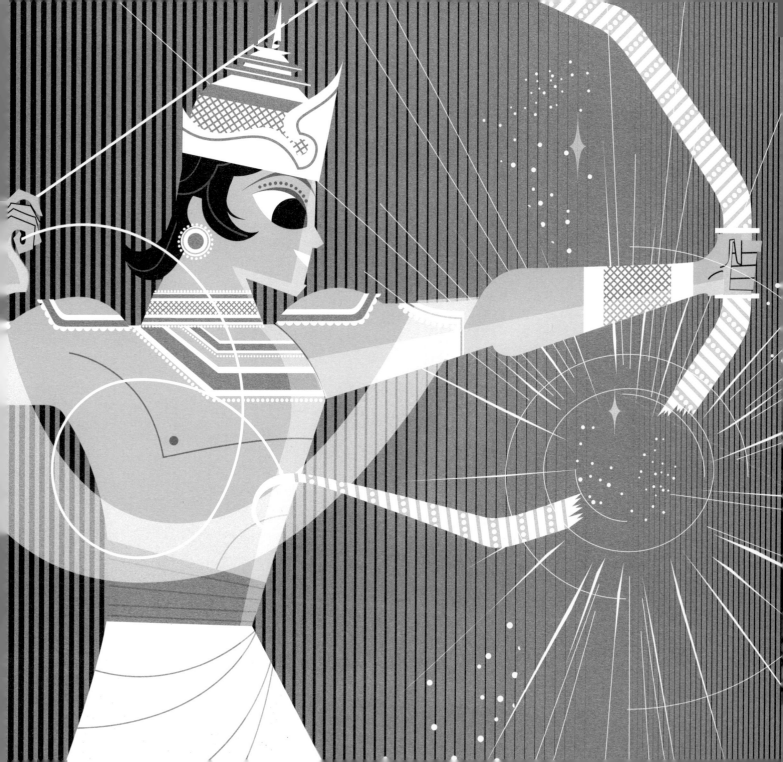

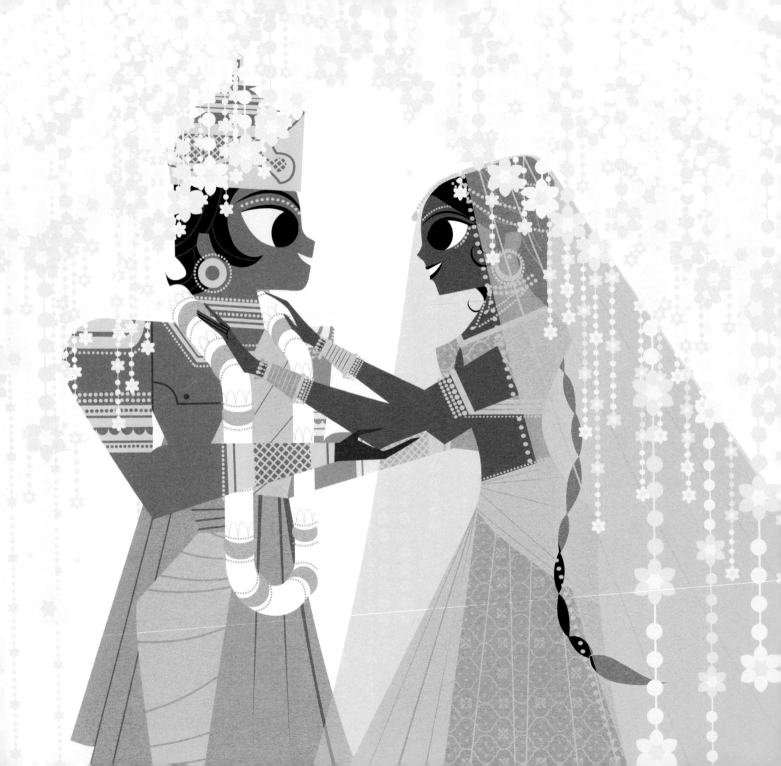

RAMA
& SITA

SITA'S FATHER IMMEDIATELY dispatched his fastest messengers to Rama's kingdom to report the good news and to invite his royal court to a wedding. Upon hearing the announcement, Rama's father and his three queens made their way to the neighboring kingdom accompanied by a grand procesion. All of the guests watched as the enchanting princess placed a garland of flowers around Rama's neck, and together they circled a ceremonial fire seven times. Thus, they were married and both kingdoms rejoiced.

Rama's father was so pleased that he announced his retirement and proudly declared Rama and Sita the new king and queen. The royal couple lived happily ever after... well, not quite.

EXILE

KAIKEYI, ONE OF Rama's stepmothers, decided that her own son, Bharata, should be the next king and hatched a plot to do away with the blue prince. The jealous queen wasn't violent, but she was manipulative and reminded the king of the two wishes he had granted her for saving his life in battle. The crafty queen immediately spoke her wishes and demanded that Bharata be made the new king and that Rama be exiled to the jungle for fourteen years.

Despite his love for his favorite son, the king was a man of his word and honored his promise to the queen. Rama was stripped of his crown at once and commanded by his father to be exiled from the kingdom.

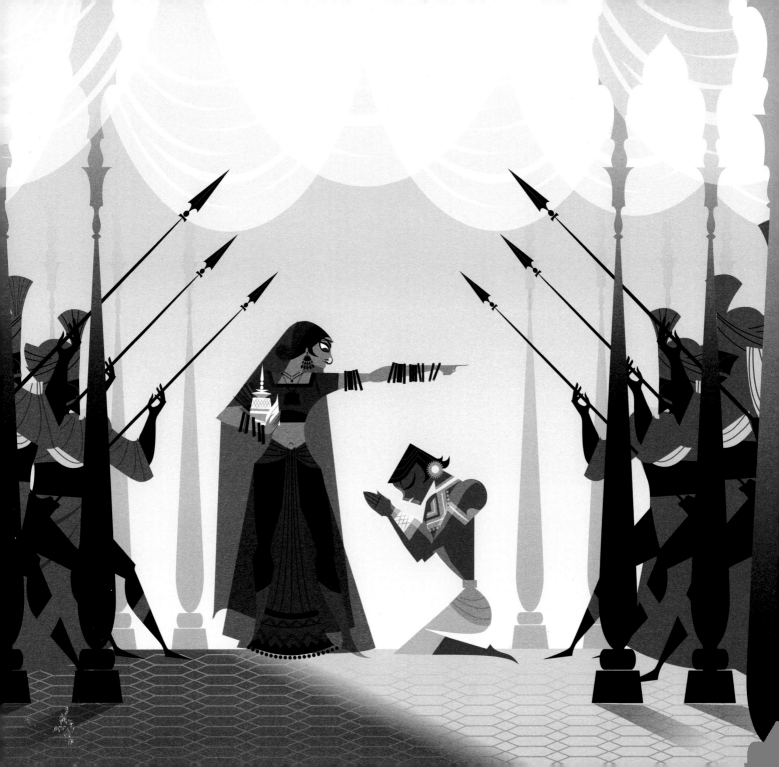

RAMA CALMLY ACCEPTED his fate and headed out for the jungle. Fortunately, the prince wasn't alone, for both Sita and Lakshman were at his side. Sadly, soon afterward, this chapter of Rama's youth came to a close when his father, consumed by guilt, died of a broken heart.

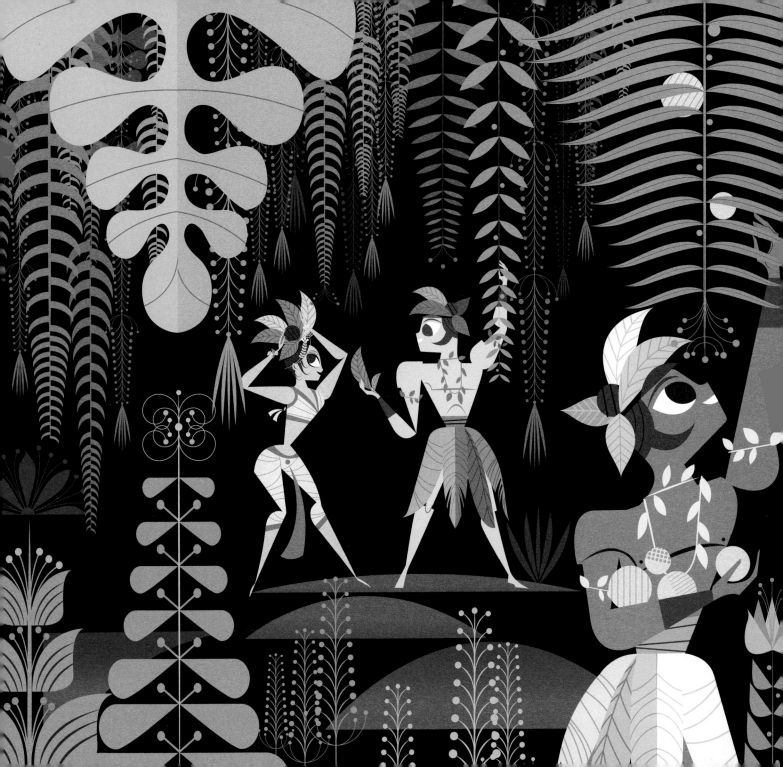

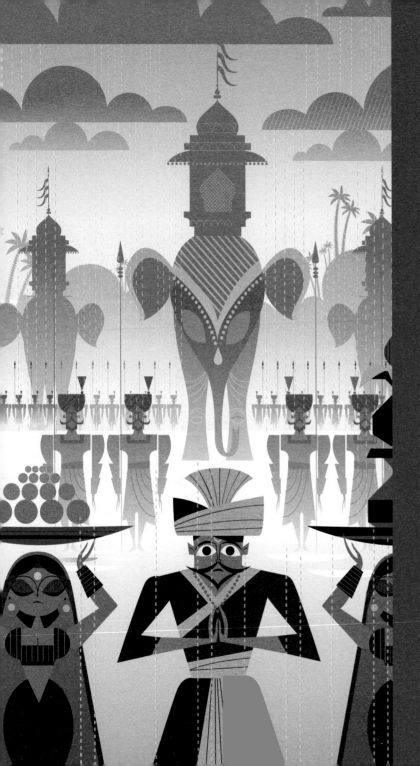

ROYAL RESCUE

EVENTUALLY, THE THREE reached a forest called Chitrakoota, where, luckily, there was no sign of demons. But before they could settle in, Lakshman spotted a royal procession led by Bharata, who had returned home from a neighboring kingdom after hearing news of his father's death; he was horrified to find that his mother had banished Rama from the kingdom. Rama was happy to see his step-brother, who fell at his feet and begged him to return to the throne. But Rama would never break a promise or disobey the order of his father.

Bharata was amazed with Rama's integrity and was more certain than ever that Rama was the rightful king. Bharata announced that if Rama would not be king, then no one would be. He then politely removed Rama's sandals and explained that he would place them upon the throne where they would wait for the true king to return.

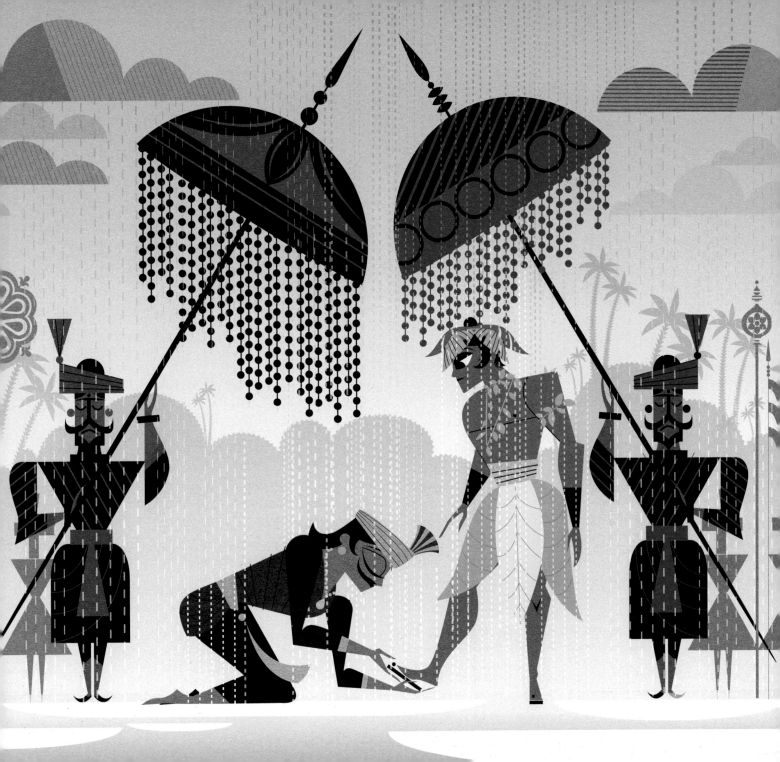

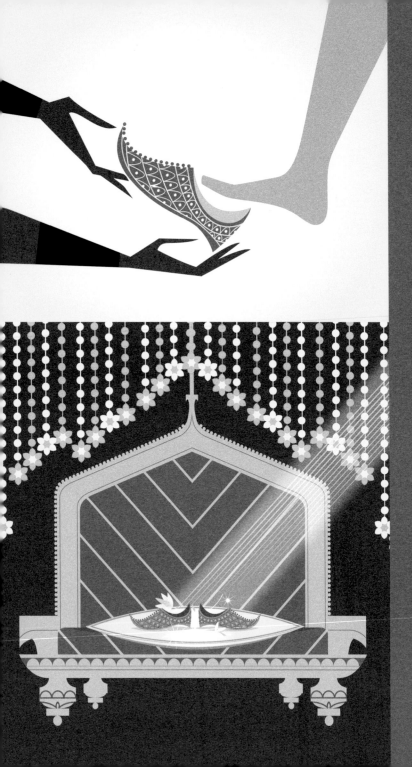

SACRED
SHOES

UNDER A CLOUD of gloom, Bharata returned to his kingdom and kept to his word. He placed Rama's sandals upon the empty throne to act as a symbol of Rama's rule. Bharata and Shatrughna then left their court and began their own exile, determined to wait out the fourteen years until Rama could return. Swindled out of his kingdom by a jealous queen and stripped of his sandals by her guilt-ridden son, Rama prepared himself for a rough road ahead.

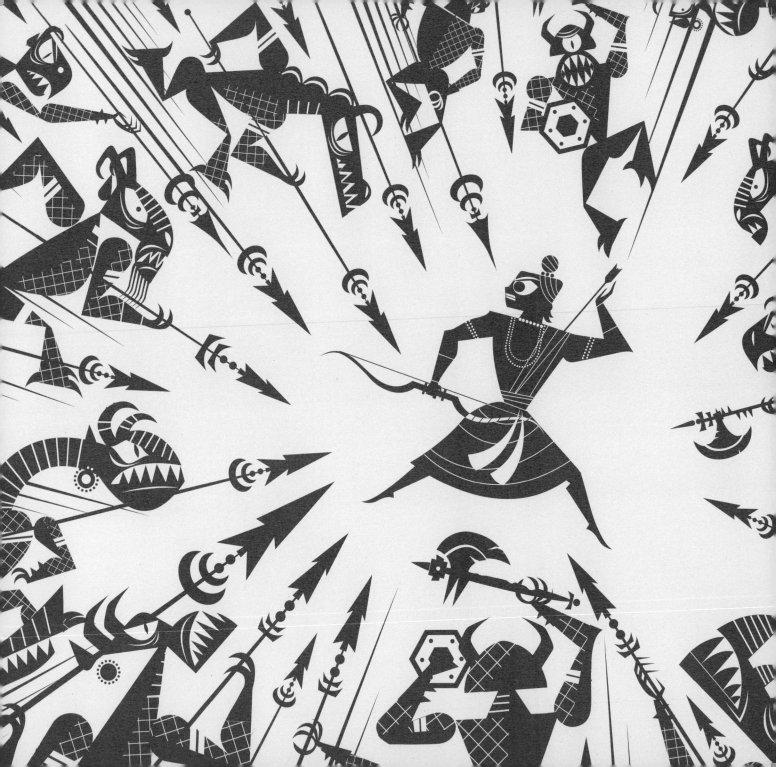

JUNGLE DRAMA

Act Two

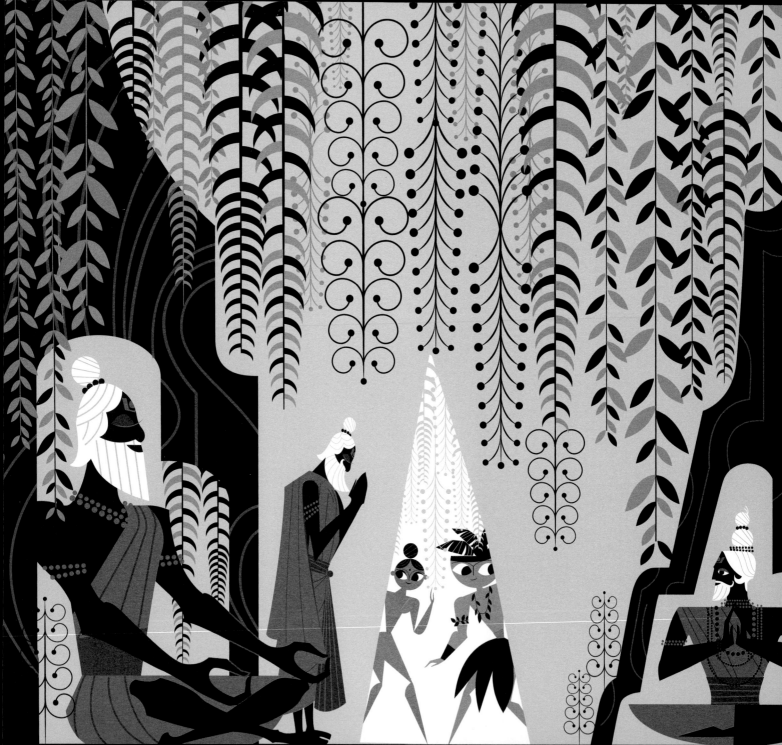

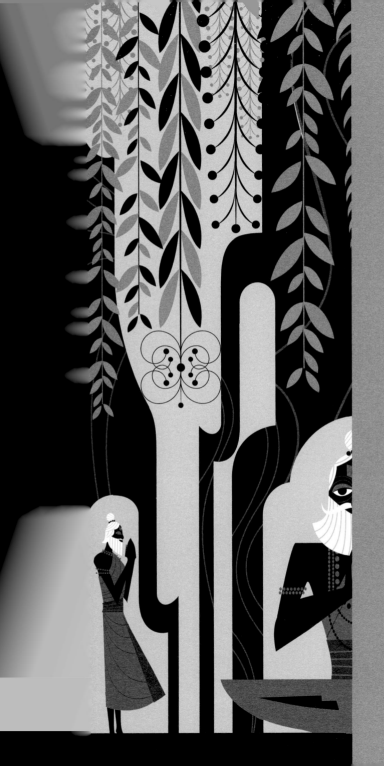

FOREST DWELLERS

WHAT DO YOU do when you have fourteen years to kill? Well, for starters, Rama, Sita, and Lakshman decided to hit the trails and explore the forest. They walked south until they came to the remote Dandaka forest in central India. As they entered the forest they sensed that the entire area was safe and sanctified by an unknown source. All three marveled at the sights of the forest and inhaled the pleasant smells of sandalwood. The sweet aromas drew them deeper and deeper into the forest until they came upon a colony of monks who lived and prayed in a forest ashram.

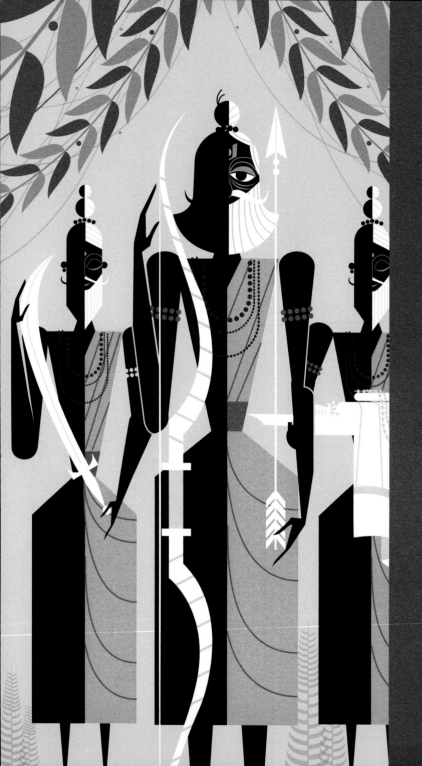

HERMIT
HANDOUTS

LAKSHMAN INTRODUCED RAMA
and Sita to the monks as the exiled prince
and princess of Ayodhya. All three were
welcomed with great reverence, which
was soon replaced with a desperate plea.
The monks explained that the jungle was
cursed with demons against whom they
had no defense.

Rama and Lakshman knew their duty
as warriors and promised to serve and
protect the colony. In exchange, the exiles
were given shelter in the ashram along
with divine gifts. Sita was presented
with a sari made from strands of pure gold
and precious jewels. A wizened sage
named Agastya then bestowed on Rama
a miraculous bow crafted for the great god
Vishnu himself. Rama was also given
a single golden arrow that could trans-
form into any number of divine weap-
ons of light and sorcery as he willed it.
Finally, the sage unsheathed a magnifi-
cent sword with a silver scabbard that
could fell any demon and presented
it to Lakshman. But Agastya quickly
cautioned that these were weapons of the
gods and their special powers would only
work in defense of an attack, for they
were not meant to start violence.

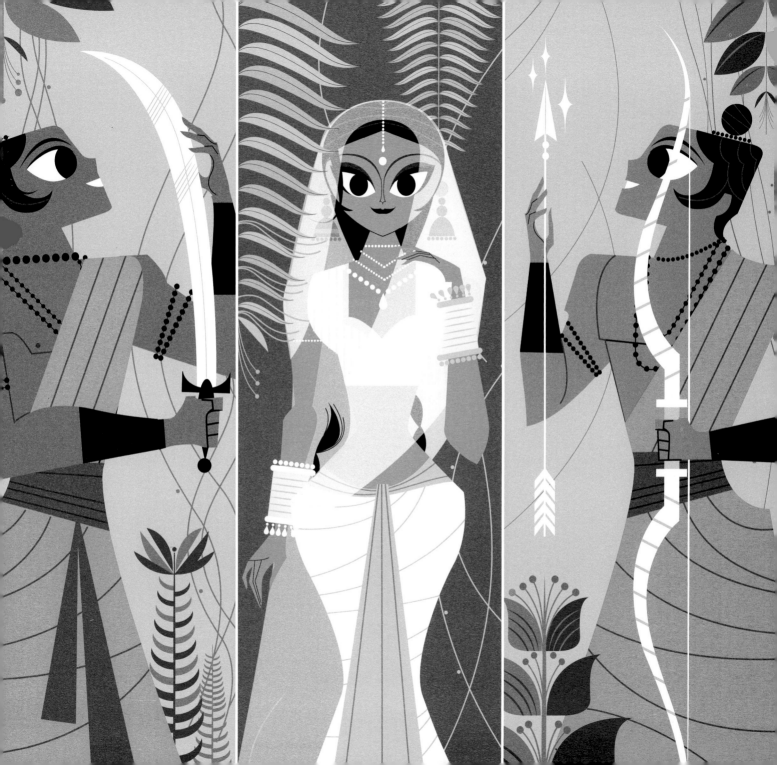

FOR THE NEXT thirteen years, Rama, Sita, and Lakshman wandered from ashram to ashram in the jungle, personally ensuring everyone's safety. They stayed at each ashram for several months at a time, and, in turn, the monks taught them about the bounty of nature. Over the years, they became experts in all variety of plants, trees, roots, and animals. Once Rama even went so far as to name an attractive variety of custard apples after Sita, calling it "Sitaphal"; in turn, Sita did the same, naming a different color of the same fruit "Ramaphal."

Eventually, the three built a cottage in the lush hills of Panchavati. They found comfort in their routine and lived peacefully under the watchful eye of a great guardian eagle named Jatayu. Little did they know that their journey was about to come to a surprising end, all because of Rama's good looks.

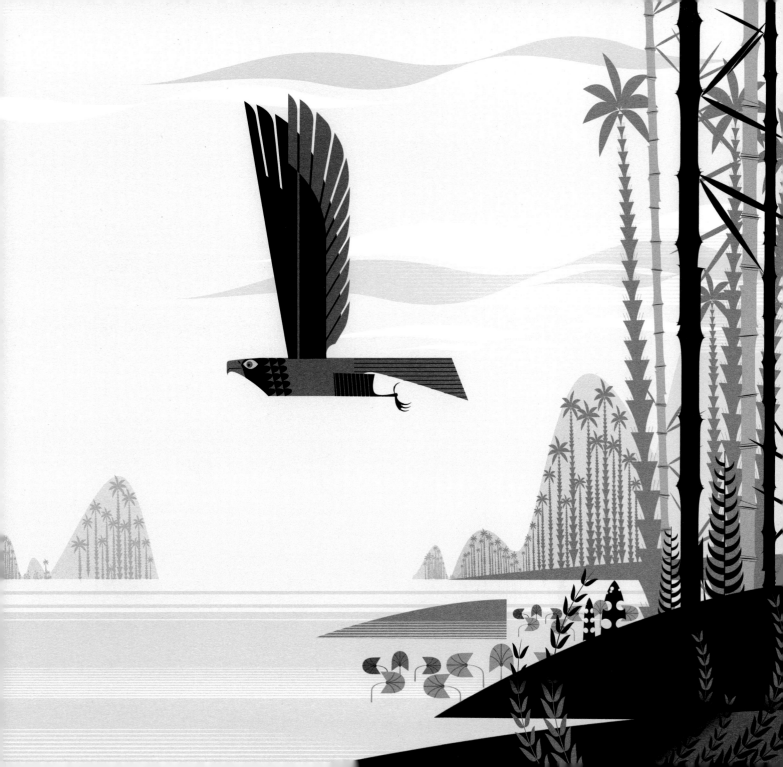

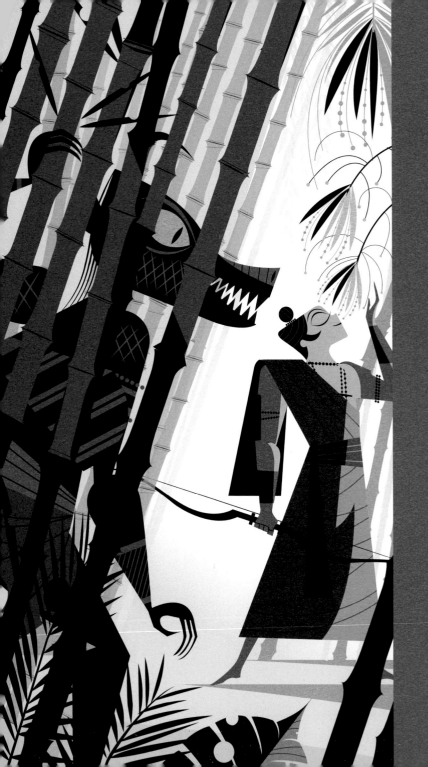

FATAL
ATTRACTION

ONE DAY A demon named Soorpanaka,
who happened to be Ravana's sister, spot-
ted Rama and fell in love with him. I know,
gross, but hey, demons have hearts as well,
even if they want to eat everyone else's most
of the time. Luckily, this shape-shifting
demon wasn't hungry. But she was love
struck, so much so that she transformed
herself into a beautiful maiden and tried
making a pass at the blue prince by show-
ing off some of her dance moves. But Rama
couldn't be tempted, for he was too in love
with Sita, who, as luck would have it,
stumbled upon the awkward situation.

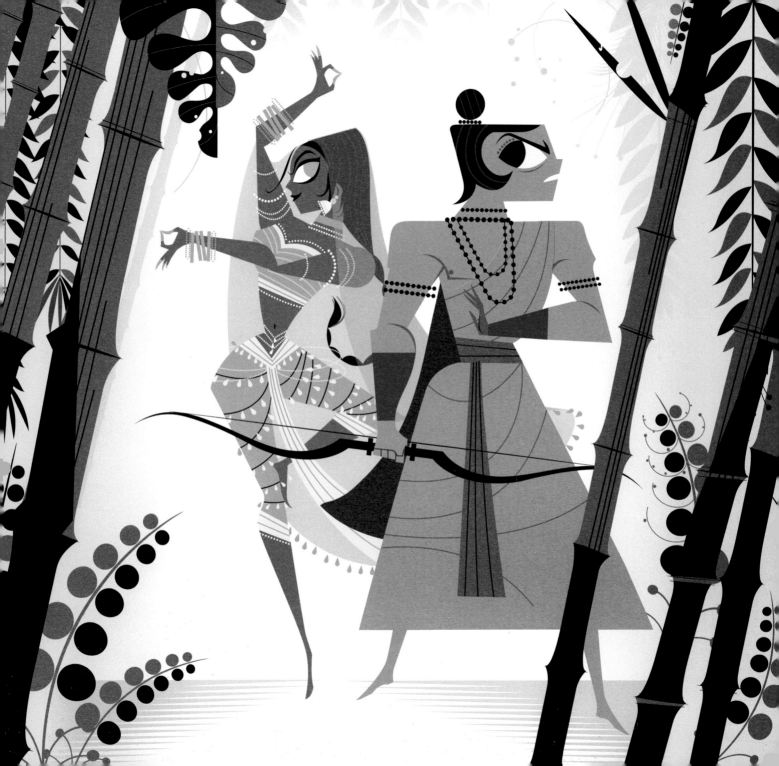

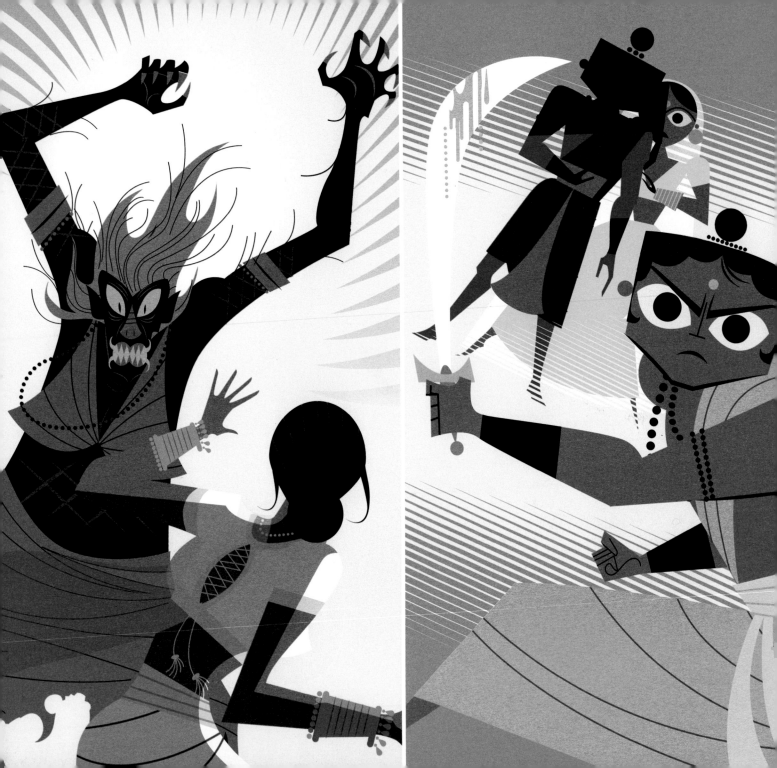

NOSEY DEMON

THE MOMENT SOORPANAKA caught sight of Sita, she flew into a jealous rage. As her face and body started to swell up with dark blood, she revealed her true demon form. Her deformed body was hulking in comparison to the delicate frame of Sita, who stood frozen at the horrible sight.

The demon bared her fangs and raised her claws toward the princess. But before Soorpanaka could strike, Rama intervened. He told the demon that if she would leave and promise never to return, her life would be spared. As he waited for her response, Lakshman burst upon the scene brandishing his sword, ready to chop the demon down. But before Lakshman could strike, Rama ordered him to lower his weapon. Soorpanaka cursed the three of them and swore that she would destroy Sita when their guard was down. The creature's words enraged Lakshman and he sent his sword flying, cutting off the demon's nose. Howling in pain, Soorpanaka fled from the jungle. The crisis was averted.... or so they thought.

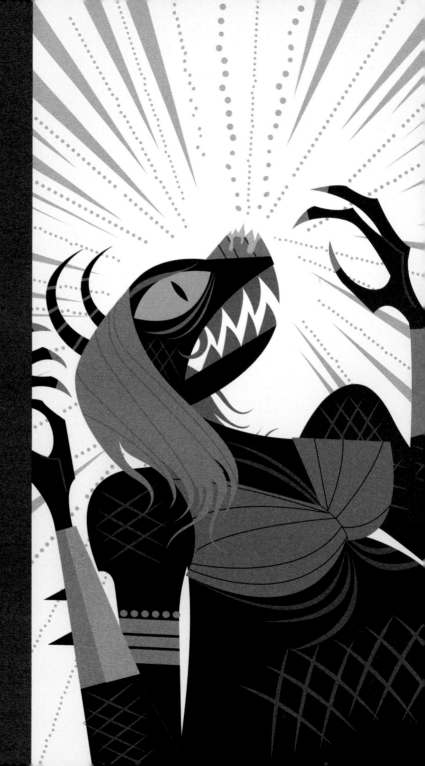

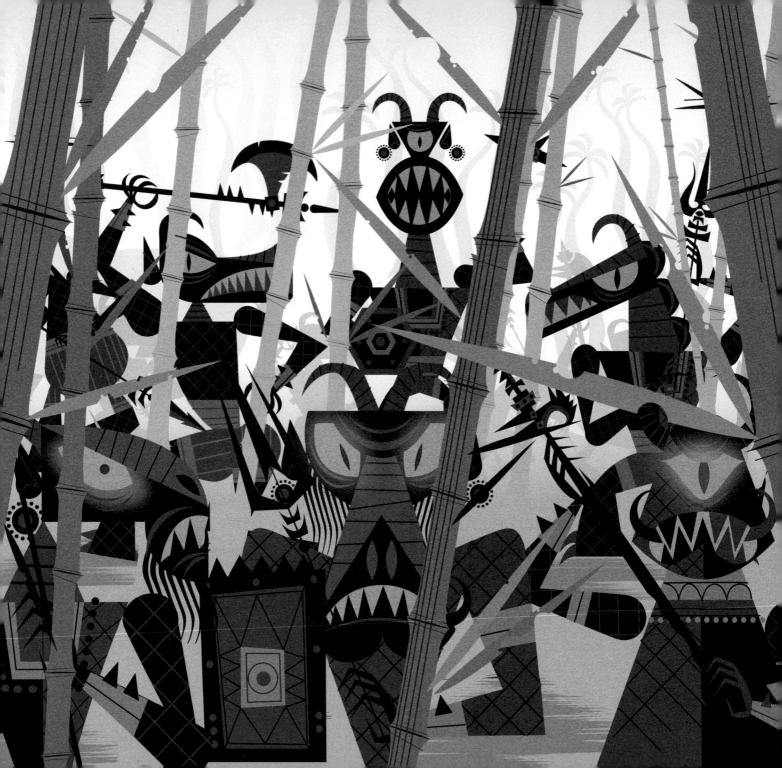

SOORPANAKA WAS SEETHING with rage and hurried back to her brother Ravana's lair. She spoke cunningly to Ravana in hopes of fanning his fury. She explained what had happened and how it was only a matter of time before Rama and his brother marched toward his domain and destroyed his throne. The demon knew this mortal was special, so he took no chances; Ravana commanded his chief to gather his entire army of thousands of demons and make ready for war. Soorpanaka personally led the death squad to Rama's doorstep to reclaim her honor.

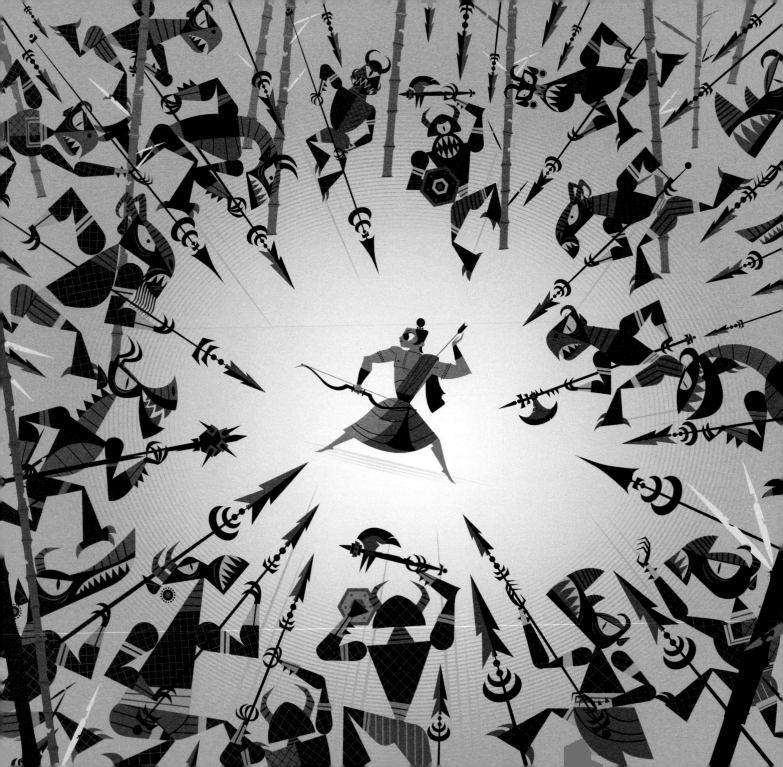

DIVINE ARROW

BACK IN THE jungle, Rama got wind of the trouble marching toward his doorstep. He immediately instructed Lakshman to take Sita to a nearby cave and guard her until it was safe. Rama armed himself with the bow of Vishnu and strung it as tightly as possible. As the terrible demon army approached, they raised a cloud of dust that obscured the skies and turned day to twilight, heightening the night-walkers' powers.

The trees all around Rama's cottage shook as thousands of glowing eyes slowly emerged from the shade of the jungle. The gruesome demons charged at Rama with all kinds of dreadful weapons, but the prince stood his ground, raising up his golden bow and notching it with the enchanted arrow. He drew the bow back so far that it formed a near perfect circle. The blue prince summoned up his training from the great rishi Vishvamitra and closed his eyes while speaking the Gayatri mantra, thus invoking the infinite power of the sun to his aid. He held the bowstring taut until the wave of demons was upon him.

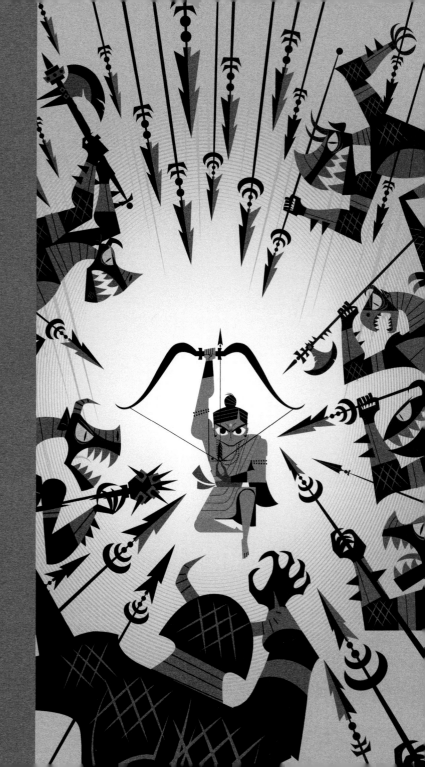

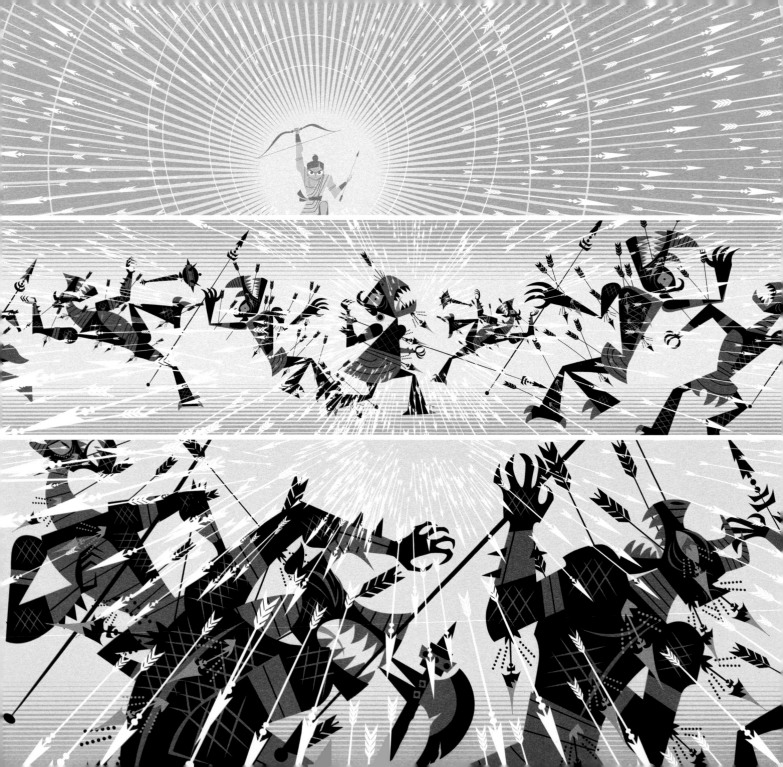

RAMA PRAYED, KNOWING that he faced thousands of foes. Luckily, a single enchanted arrow was all the blue prince needed to even out his odds. For after the special arrow was fired, it instantly multiplied into thousands of arrows that flew in every direction, casting a veil of death upon the landscape. The terrible weapon leveled an entire patch of the jungle, decimating the demon army. Countless demons were pinned to the earth by the deadly missiles, and their axes, maces, and sickles all lay shattered and ruined. After fully meeting its mark, the golden arrow reappeared in Rama's hand, ready to be used again.

AFTERMATH

FAR AWAY IN the capital city of Lanka, Ravana was surprised to see Soorpanaka back in his court. The demon brought news of Rama's victory over the jungle demons and goaded Ravana into believing that his own throne was truly in grave danger of being toppled by this mortal. The demon king looked into the future and was stunned to see his army fallen and destroyed at the hand of Rama. Soorpanaka then cunningly told Ravana about Sita and her incredible beauty and devotion, which piqued Ravana's interest. He had stolen many beautiful maidens to populate his harem and was always delighted to make another conquest.

Ravana wasn't too sure what sort of magic tricks Rama still had up his sleeve, but he wasted no time in crafting an evil plan of kidnapping and revenge.

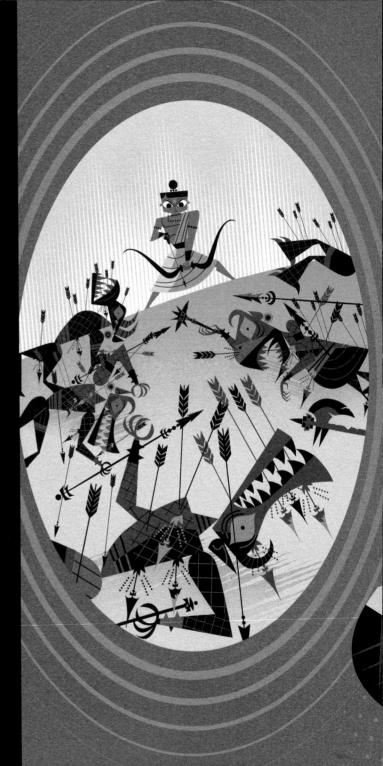

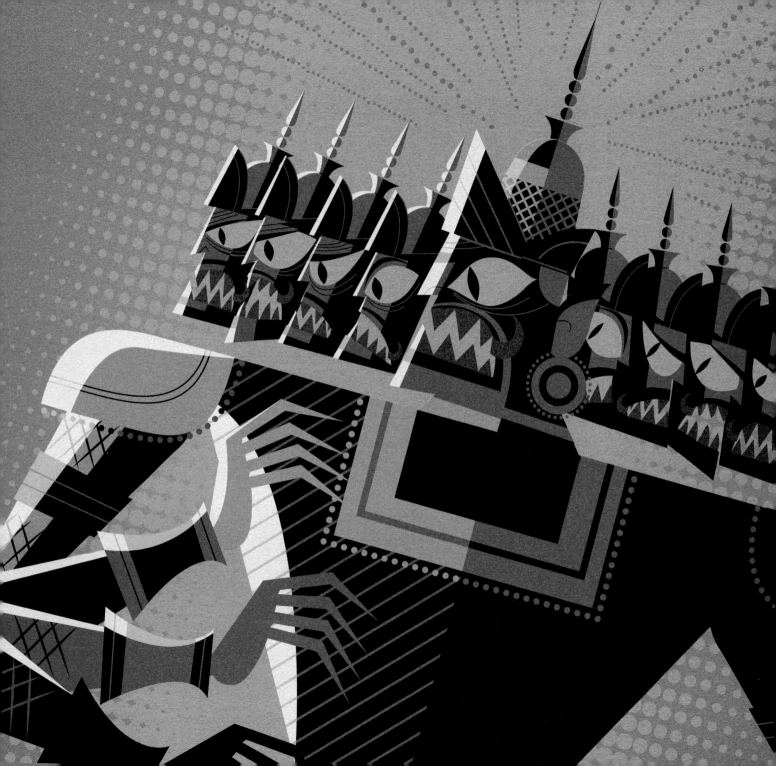

LIFE RETURNED TO normal in the jungle as nature wiped away all the evidence of warfare and the hills began to blossom once again.

One day Sita spotted a very unusual creature. It was a deer unlike any she had ever seen before. As the creature moved, its pelt shimmered like pure gold. Holding her breath, Sita moved as slowly as possible and extended her hand toward the deer. Just then, Rama and Lakshman approached through the trees, startling the deer; in one easy hop, it vanished into the jungle. Still mesmerized, Sita begged Rama to catch the animal for her. Lakshman, ever cautious, told his brother that there was something odd about the deer. Rama agreed and asked Lakshman to stay with the princess and guard her with his life while he retrieved the animal.

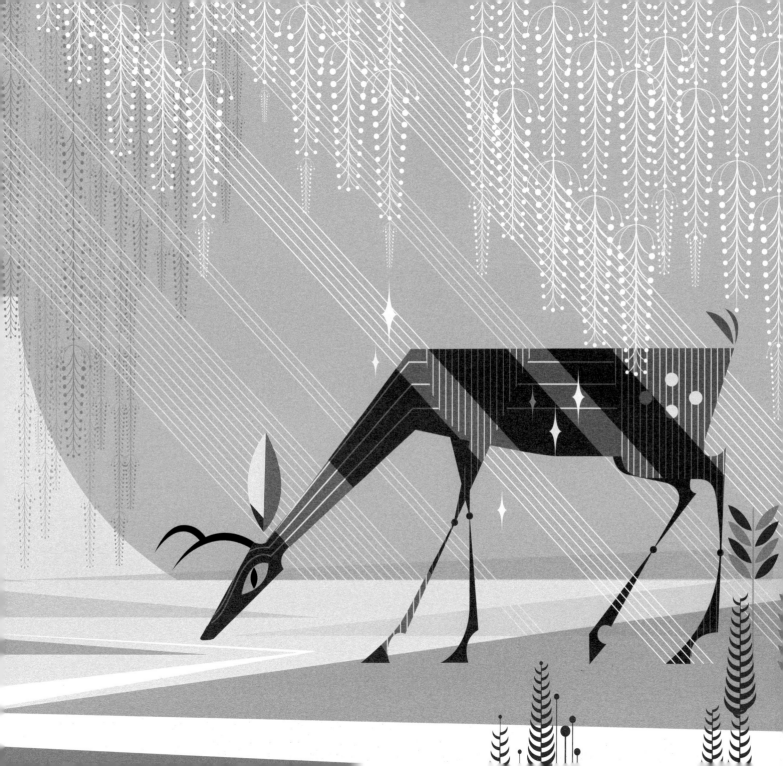

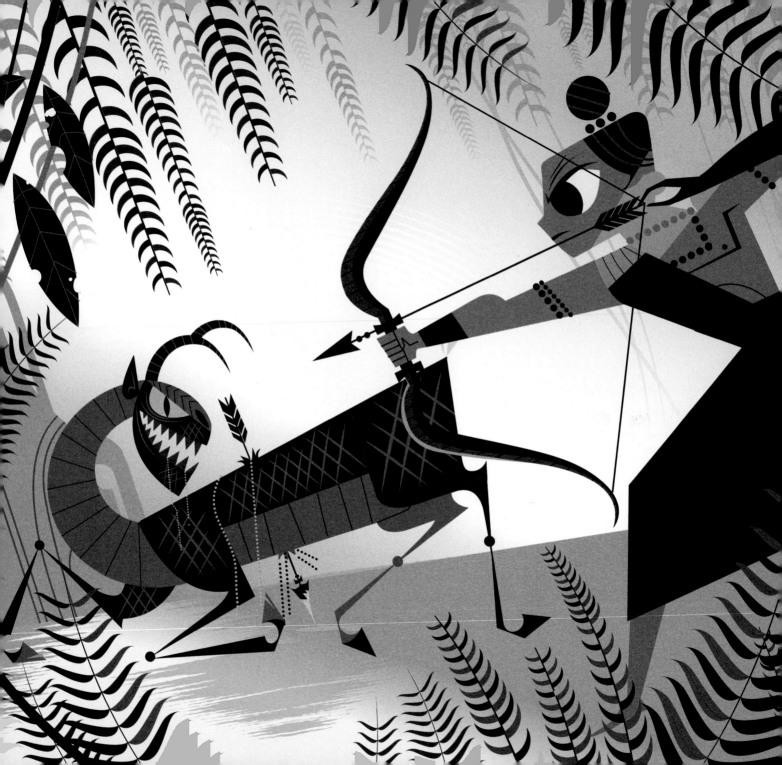

DEER OF DECEPTION

AS RAMA CHASED the deer farther and farther away from the cottage, he grew suspicious and decided to shoot it down. As the creature fell, its disguise slipped away, revealing its true identity. It was another demon (Ravana's uncle, Maricha), and even as it lay dying, it laughed at Rama for falling into a trap.

The demonic deer grinned, oozing blood from its mouth, and told Rama that today he would atone for his previous crimes. The prince had no idea what the demon was talking about, which was no surprise to the demon, since Maricha knew that the prince had forgotten taking the life of his mother, Tataka, while training with the brahmarshi. Maricha had waited for years for this day and finally felt he was on the verge of avenging his mother's death. With its last breath, the demonic deer told Rama that now it was his time to face his karma and then cried out for help, imitating Rama's voice perfectly. Instantly, the blue prince realized he had made a grave mistake.

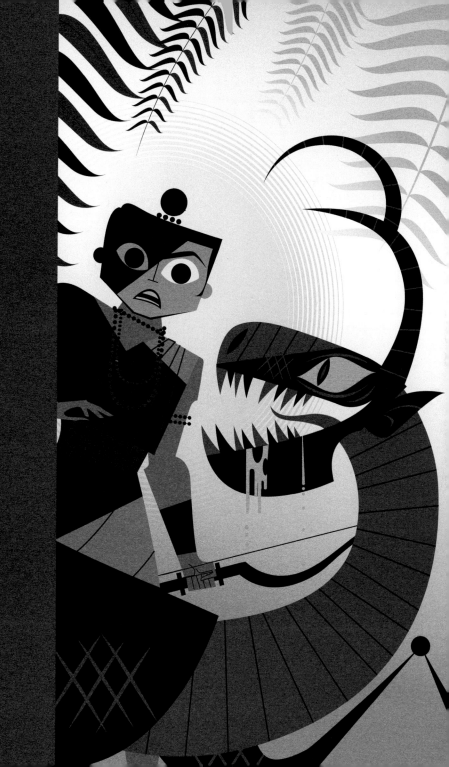

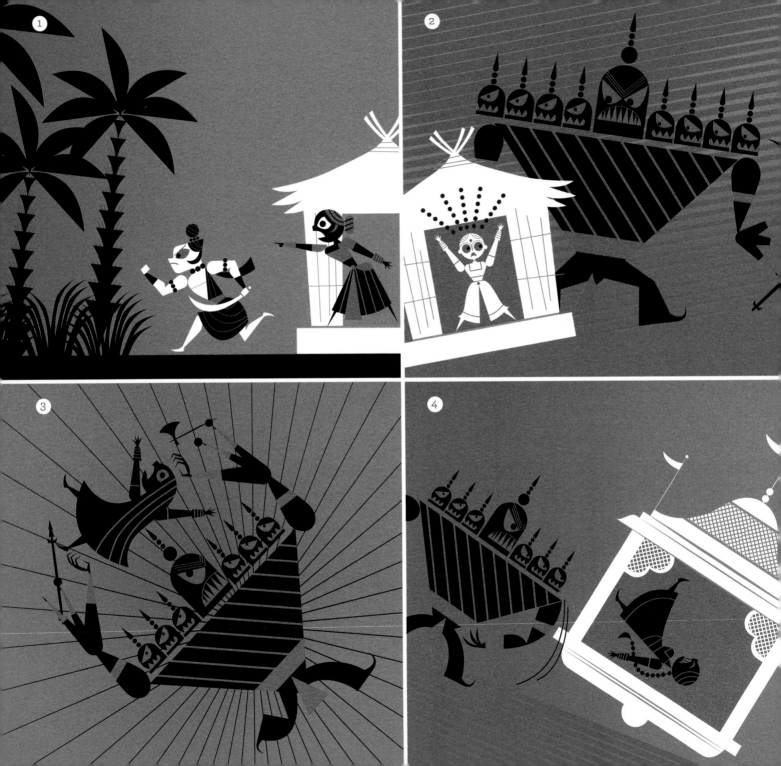

ABDUCTION

THE FALSE CRY of distress echoed off the trees, reaching Sita's ears. The princess panicked and ordered Lakshman to go and save her husband. But Lakshman did not budge, for he knew his duty was to protect Sita. He assured her that Rama could take care of himself. Outraged, Sita became hysterical and begged him to rescue Rama. The princess swore that if he did not help him she would kill herself.

Reluctantly, Lakshman gave in to Sita's pleas and ran into the jungle. But before the prince left, he used his sword to inscribe a protective circle around Sita and their home. The moment the princess was unguarded, Ravana, who was hiding nearby, approached the cottage, hatching a plan to lure the princess beyond the boundary of her protection.

Inside the cottage, Sita meditated and prayed for her husband's safe return. As she sat in contemplation, she heard the sound of a bell. The princess rushed outside, hoping it was Rama, but instead she saw a sannyasi, a penniless wanderer, at the edge of the clearing. Sita greeted the stranger and brought water and food for the old man to eat, as was the custom. Her graciousness was not returned in kind, for the moment she stepped out of the protective circle, the man transformed into the demon king. Sita froze at the sight of Ravana's ten horrible heads. The demon snatched up the princess and sped away on his chariot.

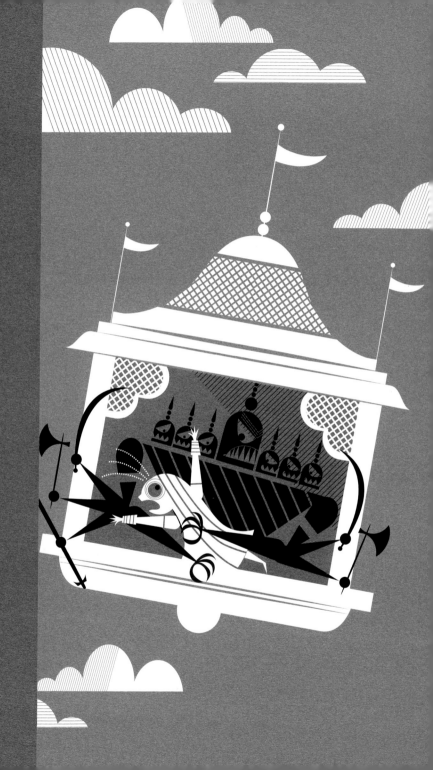

VALIANT
EAGLE

AS TEARS STREAMED down Sita's face, she called out as loudly as she could for Rama and Lakshman. But it was no use, for now they were flying high above the trees. Fortunately, the demon's chariot flew right over Jatayu's nest. The majestic eagle flapped its wings, took to the air, and in moments was in pursuit of the speeding demon.

Swooping in front of Ravana's path, Jatayu demanded that he abide by the code of kings and release Sita at once. But Ravana had no intention of honoring this code. The demon took up his bow and began firing arrows at the eagle, but Jatayu flapped his mighty wings, causing a mini tempest that deflected the arrows. The eagle clawed at the chariot with his mighty talons and snatched Ravana's bow, shattering it easily. But, Ravana would not be bested by the mighty beast. With a powerful swing of his sword, the cruel demon cut straight through the eagle's wing, adding yet another crime to his notorious list. The mighty eagle fell from the sky as Ravana's chariot streaked across the horizon and disappeared.

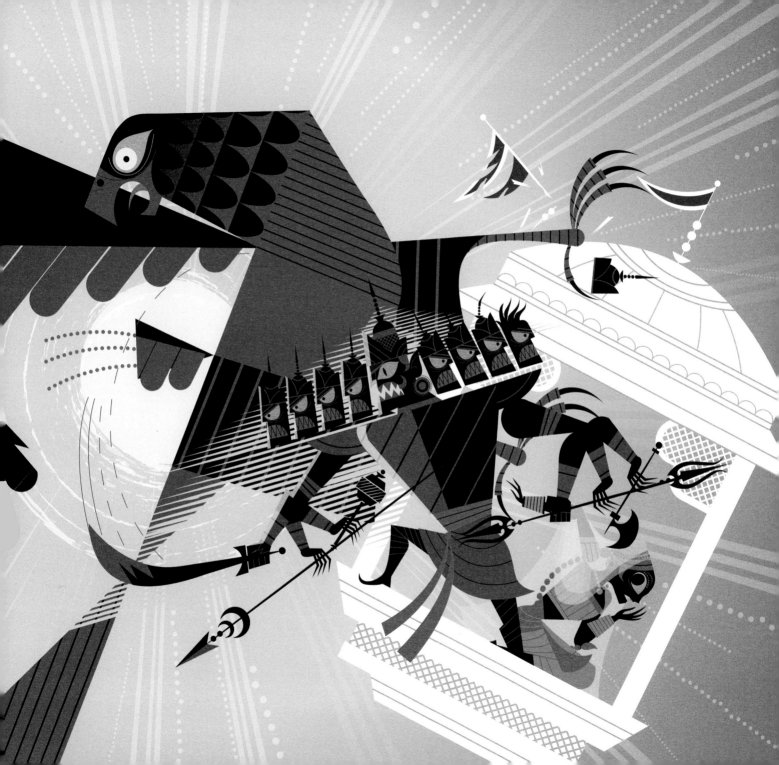

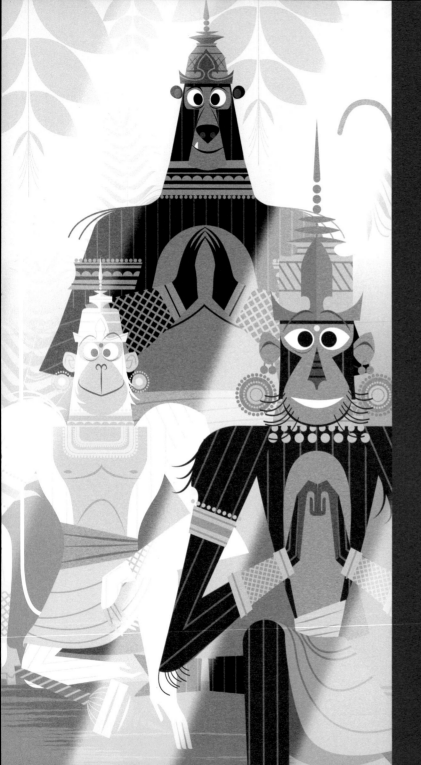

SEARCH FOR SITA

BY THE TIME Rama and Lakshman figured out what had happened, Sita was long gone and the guardian eagle was dead. Rama felt defeated, but Lakshman urged him not to give up hope. Together, they began looking for the princess.

As the brothers made their way south, they entered the jungle kingdom of Kishkindha, where they came upon a couple of monkeys and a bear. The furry creatures introduced themselves as Hanuman, the white monkey; Sugriva, the exiled king of the vanara (monkey) tribe; and Jambavan, the black bear and clan chief. The brothers were relieved to tell their story, recounting their exile and the kidnapping and stating their quest to find the missing princess. The animals felt sorry for Rama and offered to help. The warriors were surprised by their generosity but didn't think that a few monkeys and a bear could be much help in finding Sita. Sugriva and Jambavan assured Rama that he would also have the help of their families.

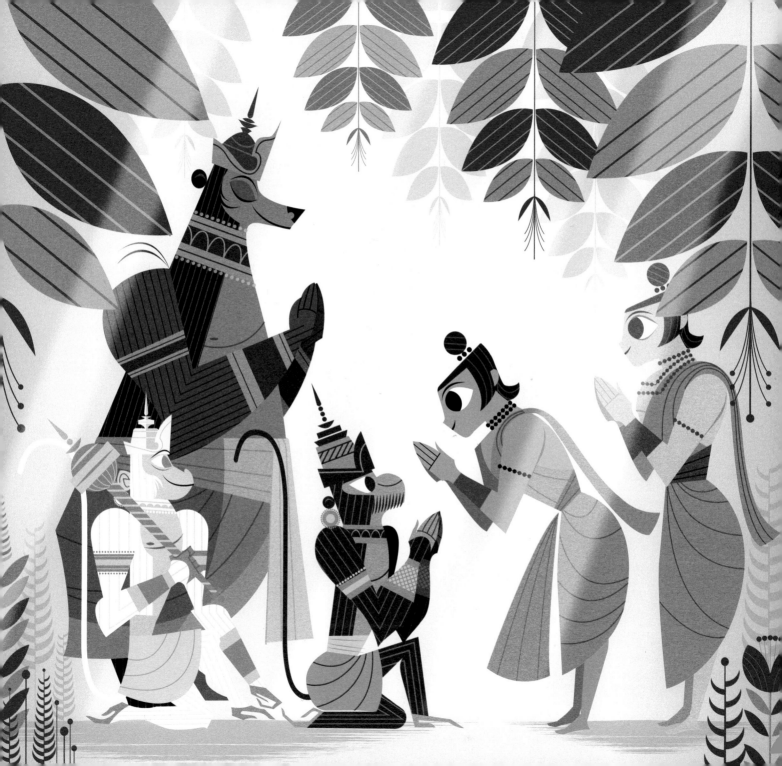

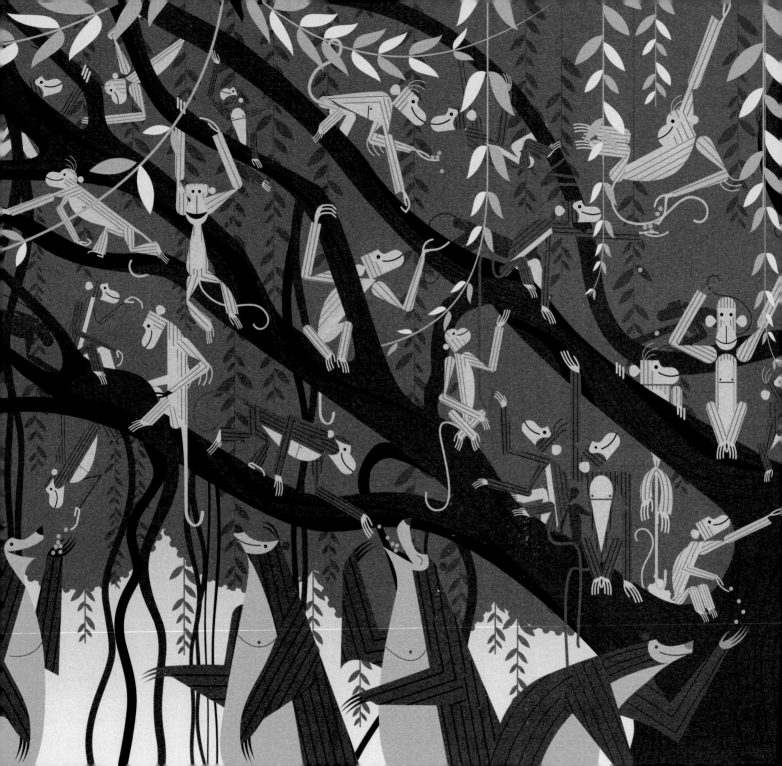

THEIR *ENTIRE* FAMILIES.

AND SO BOTH the monkey and the bear tribes searched high and low for a month,

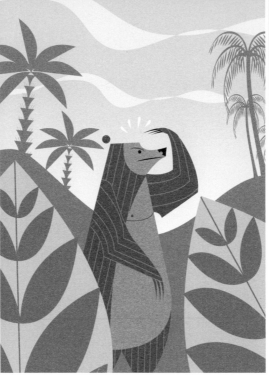

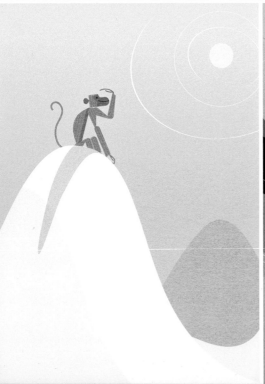

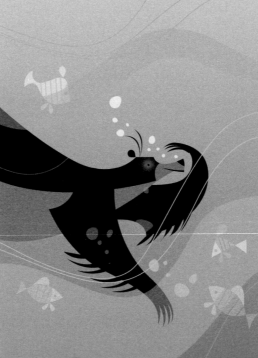

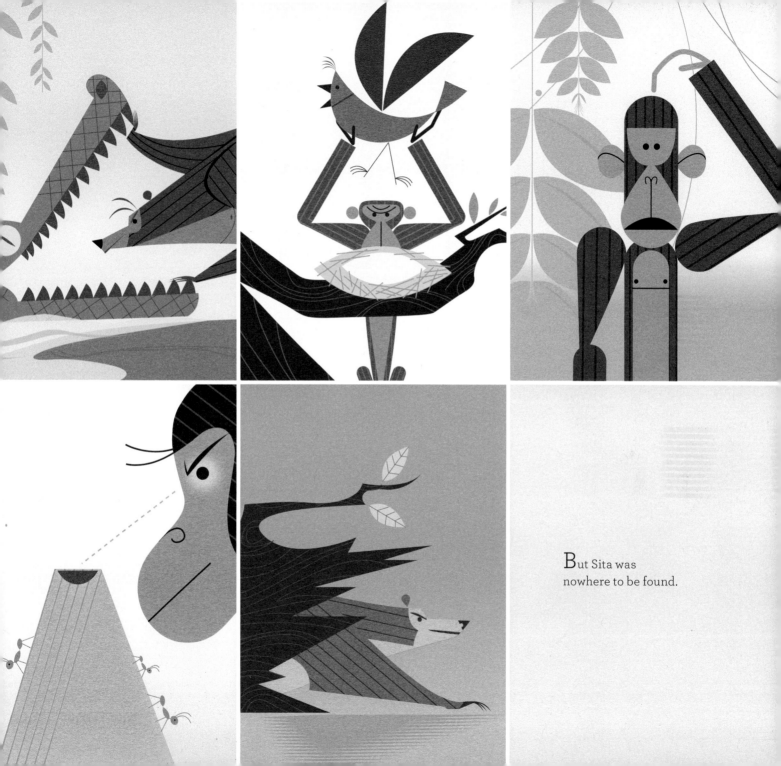

But Sita was
nowhere to be found.

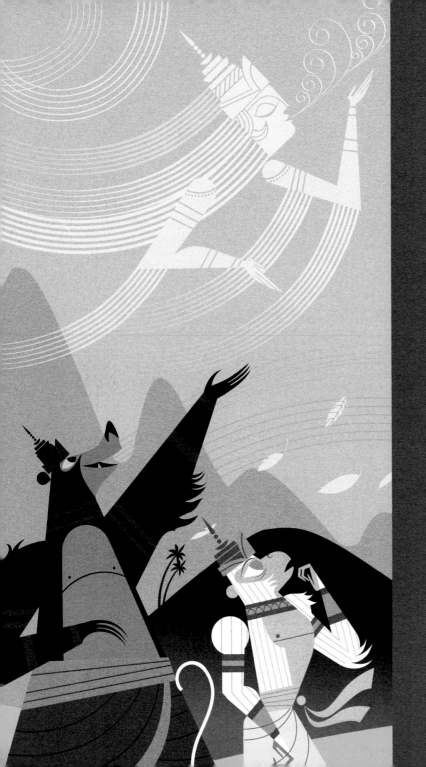

MONKEY GOD

WHEN THE SEARCH party reached the southern tip of India, and Sita had not been located, everyone lamented their inability to cross the ocean and continue the search. Even Hanuman was left scratching his head. Luckily, the old bear Jambavan had an idea. He didn't know where Sita was, but he knew a secret about Hanuman. In his youth, Hanuman had been cursed with an inability to remember how powerful he was (in order to keep him from using his powers to annoy the meditating sages). Jambavan decided to break the promise he'd made to the gods and whispered in the monkey's ear, telling him that he was no ordinary monkey but in fact the son of the wind god. Instantly, Hanuman's divine powers were restored, transforming the monkey into a giant and sending his head up toward the clouds. From his new vantage point, Hanuman easily spotted Ravana's palace upon the island of Lanka.

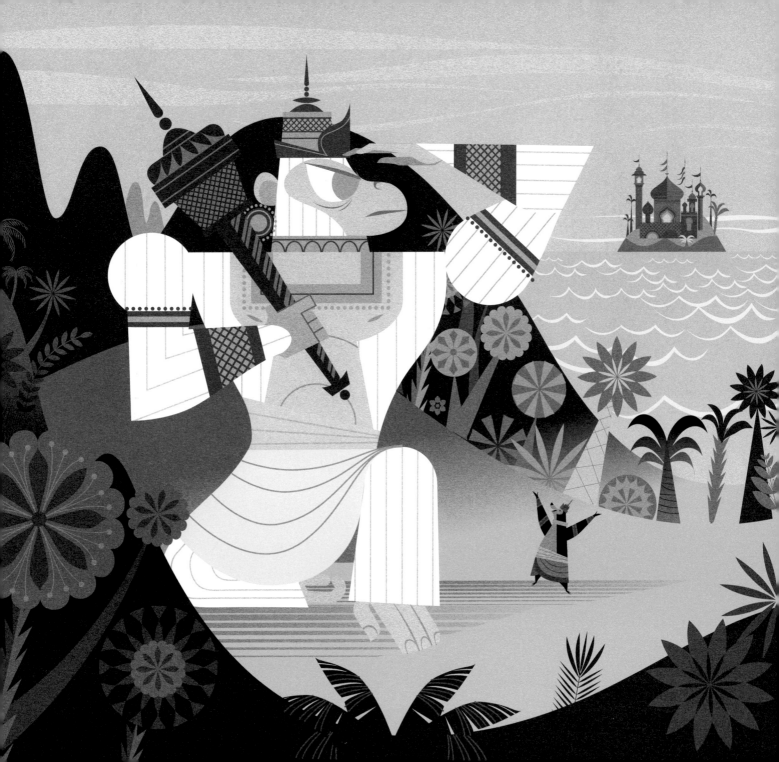

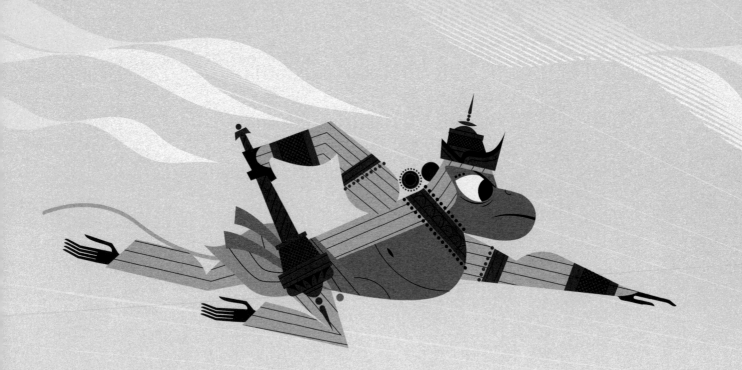

HANUMAN SQUATTED DOWN, coiling up his energy. With a look of determination he shot forward toward the ocean, and then, in one massive step, he leaped off the tip of the continent. As he jumped, he shouted, "Jaya Rama!" (Victory to Rama!) in a booming voice, and then he was airborne. The group on the beach gazed in amazement as the vanara was now flying straight toward Lanka, the land of demons.

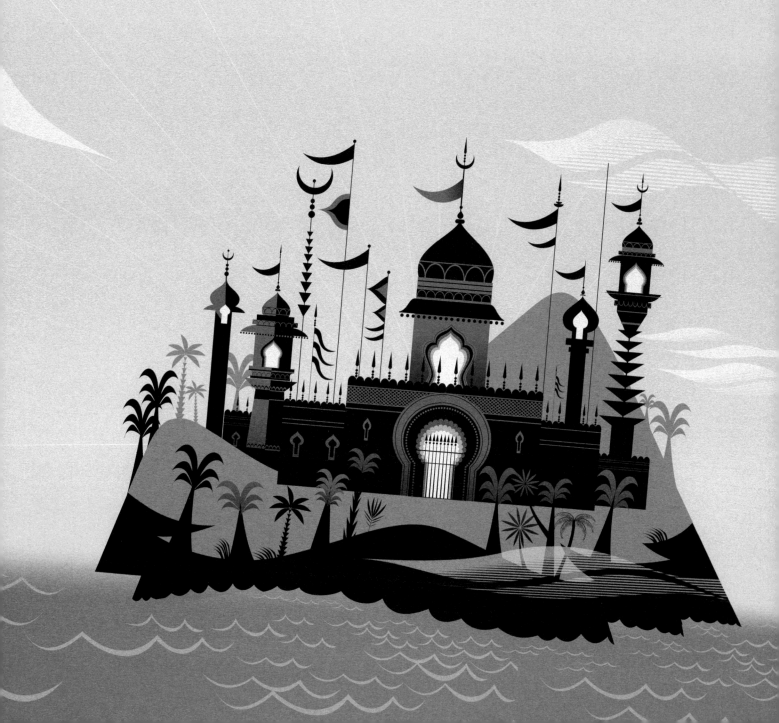

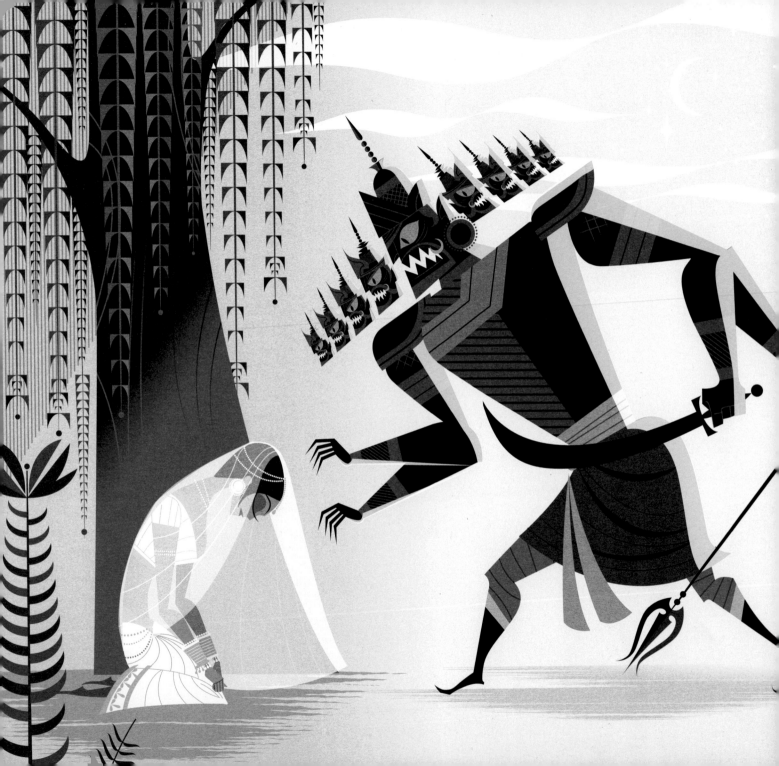

PRINCESS PRISONER

BEFORE LANDING ON the demon island, Hanuman shrank himself back down to the size of an ordinary monkey so that he could sneak into Ravana's palace. There he followed the faint sound of sobbing, coming from a small grove of Ashoka trees. Stealthily making his way through the foliage, Hanuman saw several ogresses guarding the hunched form of a crying woman. Despite her gloom, she was clearly a goddess whose luster was obscured beneath a veil of grief. Hanuman had no doubt that he had found Sita, and he smiled knowing that the search was over. Just then the garden doors burst open and Ravana entered, demanding that Sita become his queen or wind up as his dinner. Ravana gave the princess one month to decide.

That night, after everyone was fast asleep, Hanuman approached Sita and explained that Rama had mobilized an army and was preparing to rescue her. Sita turned away coldly, thinking this was yet another one of Ravana's disguises. Undeterred, the vanara told Sita that the blue prince had not forgotten his oath to always protect her, which was symbolized by the wedding ring she gave him. Hanuman then took out the ring, which Rama had entrusted to him, and presented it to the princess. Sita recognized it right away, and, with tears of joy now streaking her face, she blessed Hanuman for renewing her hope.

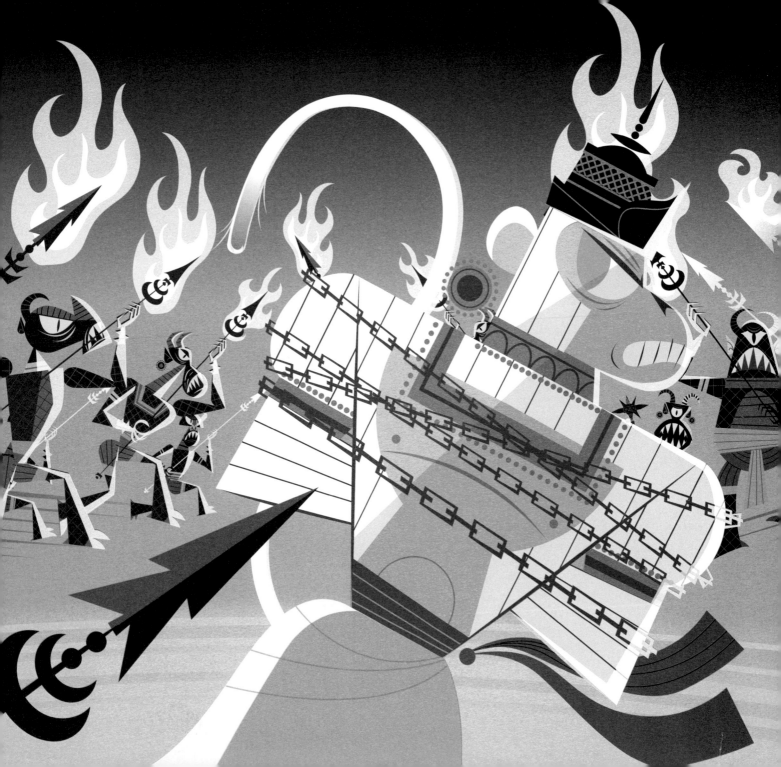

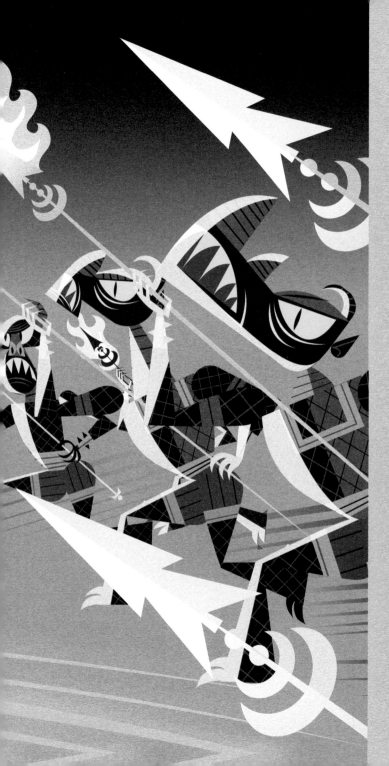

BURNING
TAIL

EXCITED TO BRING back the good news of Sita's discovery, Hanuman was caught off guard as he was leaving the palace. The demons quickly surrounded the vanara, who stood unarmed with his palms joined in a gesture of peace. With spears and swords held to his throat, Hanuman humbly surrendered and politely explained that he was an envoy with an urgent message for King Ravana.

The demons bound Hanuman in chains and brought him before the demon king. He respectfully told Ravana that Rama had raised an army that would fight for Sita's freedom unless she was released. Each of Ravana's many heads laughed mightily at this news as his eyes flared with rage. His teeth flashed as he declared death to Rama—and death to his messenger. The demon king then deemed that since this messenger was clearly a spy, he would first be tortured with fire, smelling his own flesh burn. Looking Hanuman over, the demon decided to burn what was most precious to a monkey; he ordered that the vanara's tail be set on fire. Hanuman's tail was wrapped with oil-soaked rags while the guards waved torches near his face, taunting him. Then, slowly, a flame was brought near his back and then down to the tip of his tail. The vanara's lips trembled, but it was not fear that moved his mouth: He was chanting a mantra. Over and over again he whispered Rama's name: Rama, Rama, Rama. . . .

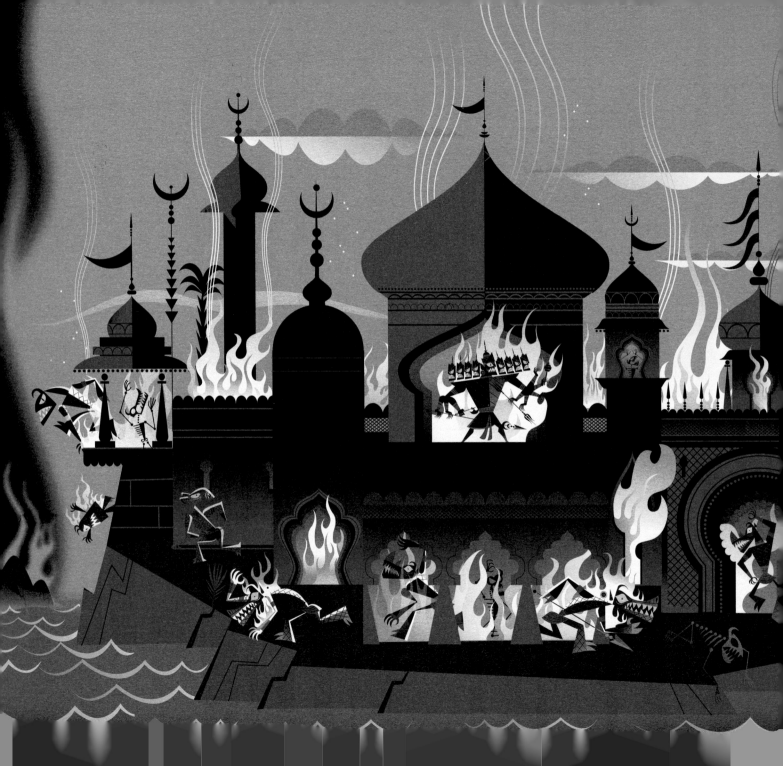

FINALLY THE OIL-SOAKED rags were lit on fire. But before Hanuman could feel the pain of the fire, he used his divine powers to extend his tail, keeping the flames far away from his body. The spectators stared at the growing tail, confused and mesmerized by the sight. Snapping his chains, Hanuman flicked his winding tail to and fro, setting Ravana's court ablaze. Hanuman jumped across the roofs of Lanka, his long tail dragging behind him, leaving a trail of fire as the entire city was set ablaze. Taking flight once again, Hanuman could see that all of Lanka was engulfed in flames. But deep within the fire and smoke there was one patch of safety where Sita was being held. Confident that he had fulfilled his mission, Hanuman finally let his extensive tail dip into the ocean, extinguishing the flames. The proud vanara then leaped toward home, buoyed by the satisfaction of destroying Ravana's capital city.

ENDLESS
WAR
Act Three

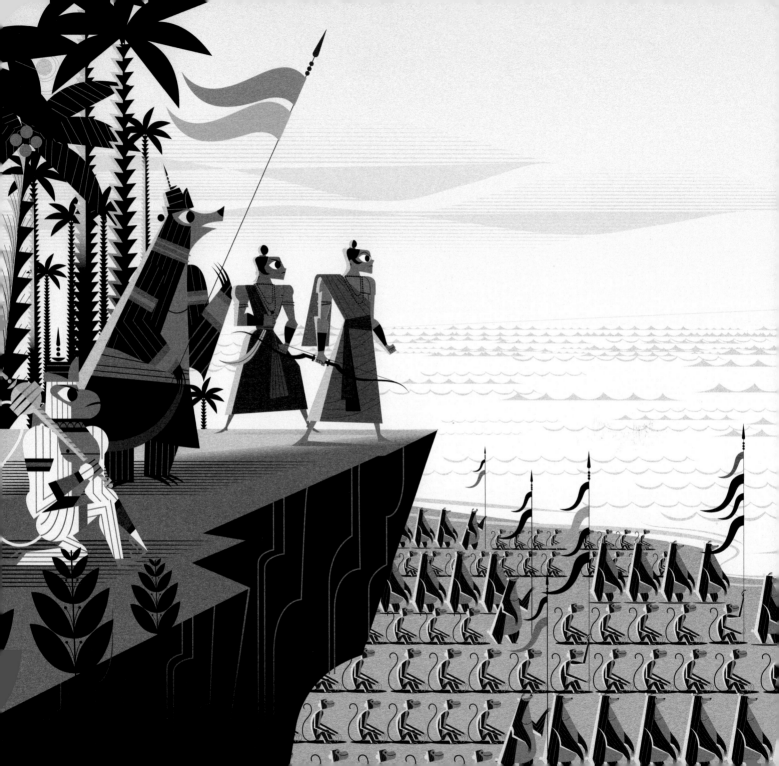

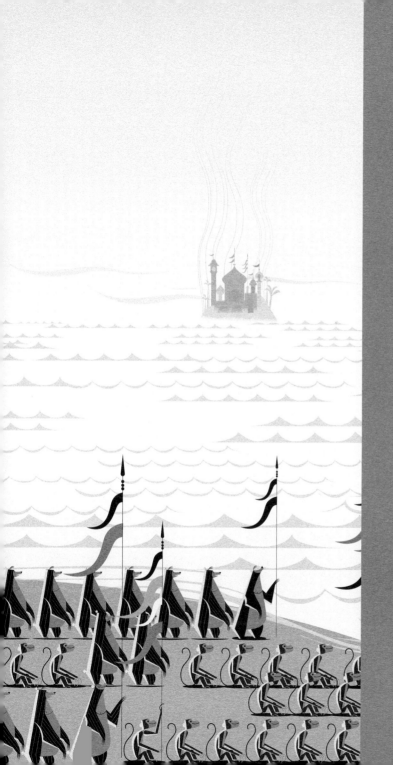

OCEANS APART

UPON HANUMAN'S RETURN, Rama's spirits soared with the news of Sita's discovery. The vanara reported every detail of his adventure, telling the prince of all the things he had observed during his trip to Ravana's capital city. While he spoke, a faint trail of black smoke lingered over the horizon, evidence of Hanuman's fiery escape from Lanka.

King Sugriva informed Rama that their army could commence the march toward Lanka immediately. Rama and Lakshman led the procession, relieved to finally be on their way to free Sita. But when the great army reached the shoreline of South India, they were unexpectedly stalled by the vast salty ocean. It turned out that none of the animals could swim, and from where they stood, the island of Lanka seemed to be another world away. Stymied by yet another roadblock, Rama fasted and prayed for a solution, all to no avail. Eventually, he grew angry and began to shoot fiery arrows into the waves, threatening to burn up the entire ocean so his army could cross. Fearing the blue warrior's wrath, the ocean deva, Varuna, emerged from his watery home and approached the shore. He explained that as much as he would love to help, it was impossible for him to part the waters, for even he, a mighty deva, was a slave to Ravana.

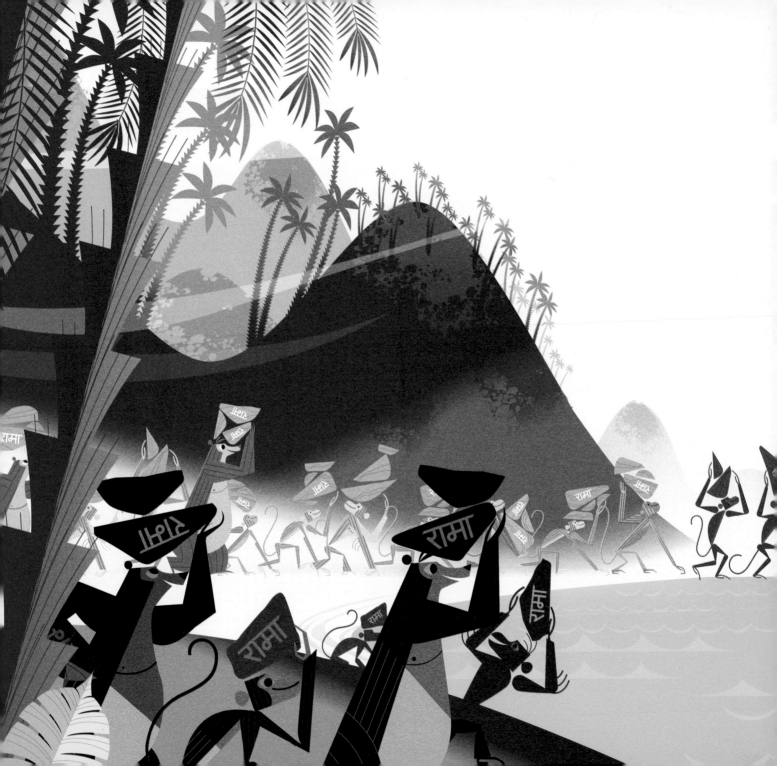

LUCKILY, JAMBAVAN WAS very clever and figured out a solution to the problem. The bear remembered that if a god's name was written on a stone, it would float. After trying several names on stones that sank, Hanuman tried Rama's name, and, to everyone's surprise, the stone floated. Sugriva and Jambavan were thrilled and ordered their tribe to begin building a bridge of stones with Rama's name written on them. The entire army of vanaras and bears gathered up every pebble, rock, and boulder from the beach and set them upon the ocean. It was as if an entire section of the mainland had been stretched out into the sea. For five days the animals worked nonstop to build what came to be known as "The Great Bridge of Rama."

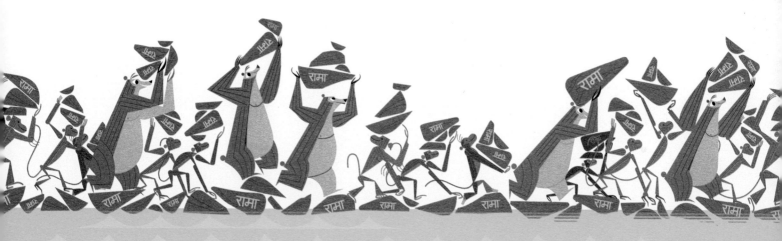

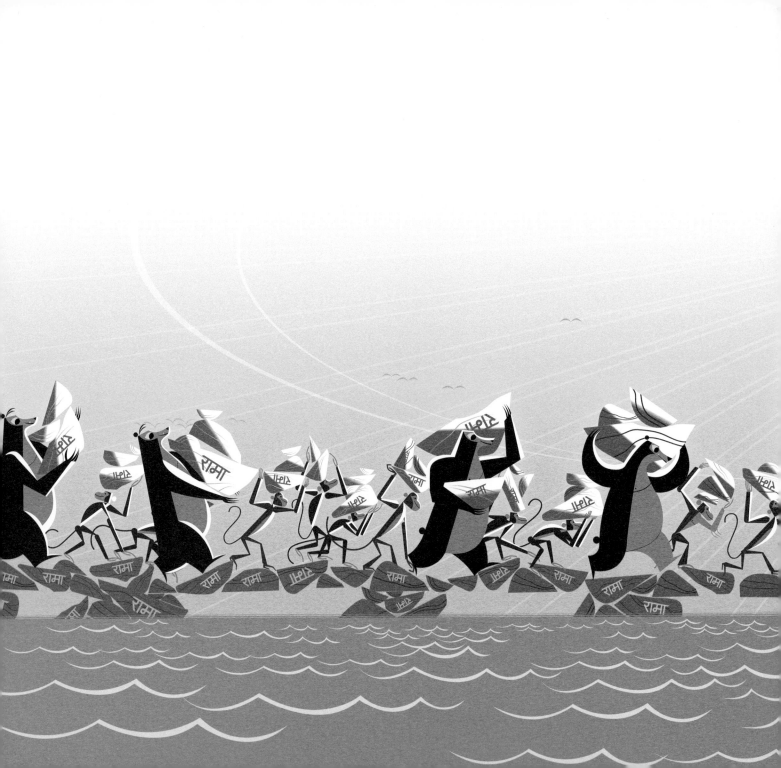

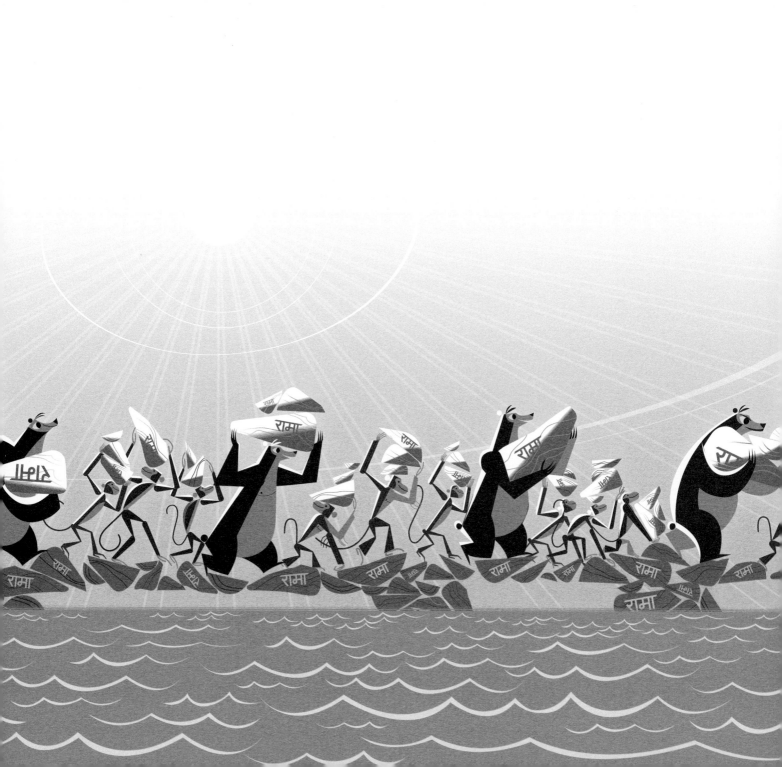

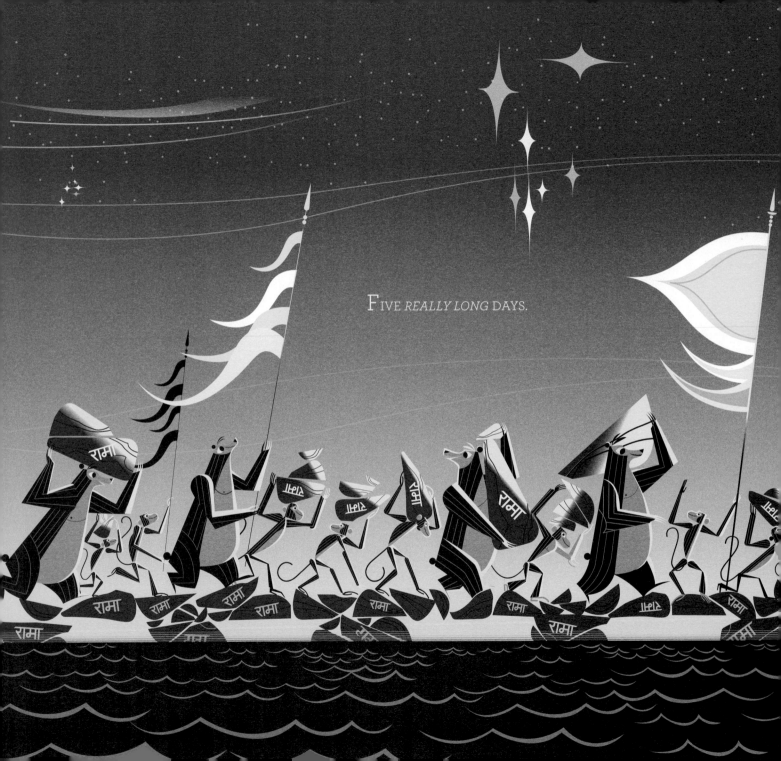

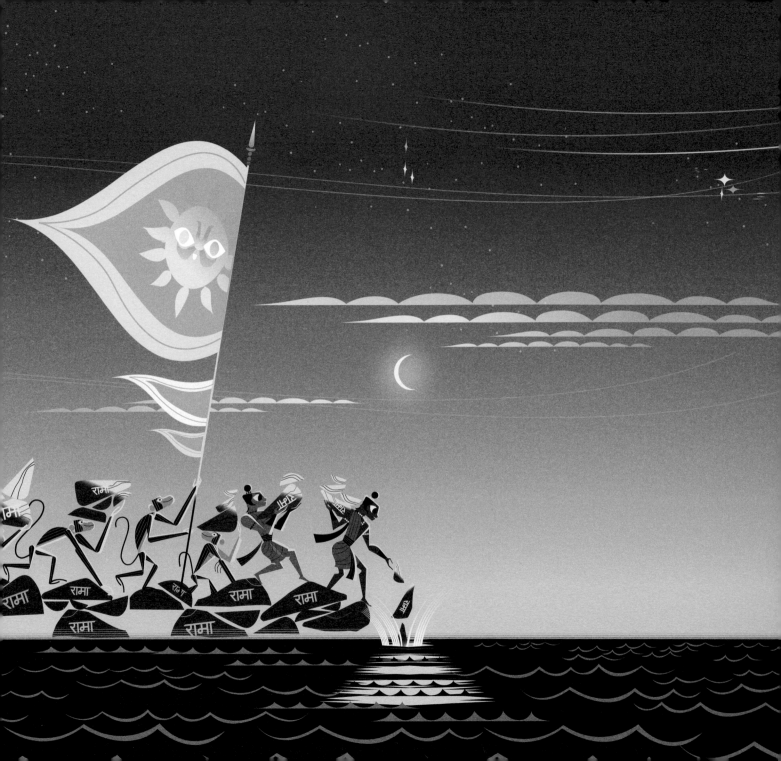

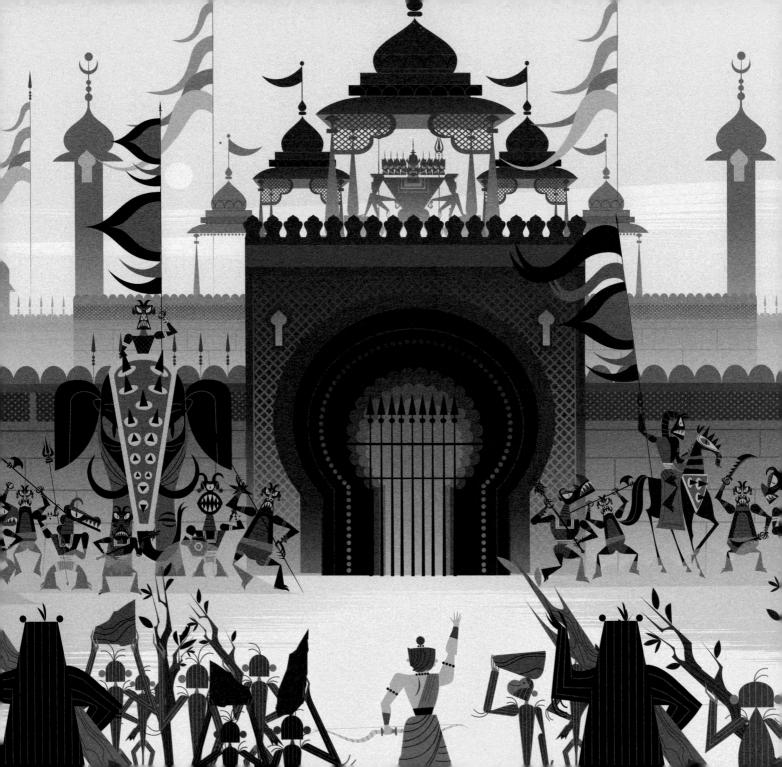

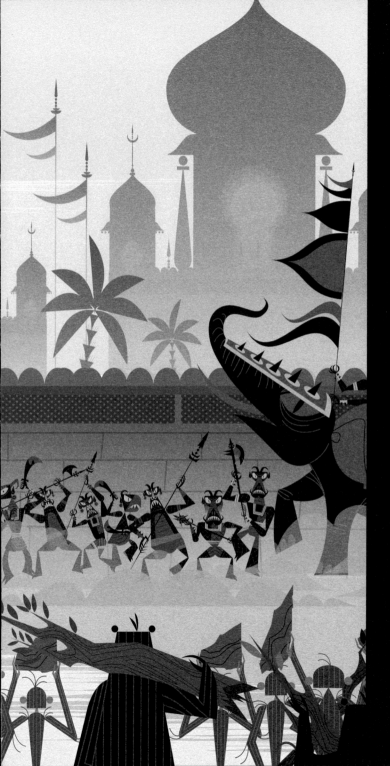

BATTLE OF LANKA

ONCE THE BRIDGE was complete, Rama's army marched across it to the island of Lanka. At the gates of Ravana's capital city stood the imperial demon army equipped and ready for war.

In keeping with the rules of engagement, Rama dispatched a final messenger to ask Ravana to release Sita and avoid war and bloodshed. But the demon king laughed off the request, declaring that the only thing Rama would gain from Lanka was his own death. Having no further choice, Rama instructed his army to make themselves ready for an attack. The bears uprooted trees and boulders, while the vanaras tore down branches and gathered stones, making weapons with whatever might crack a rakshasa skull. The jungle army stood ready to attack at Rama's signal. The blue warrior waited for the auspicious moment when the sun reached its zenith in the sky. The demon army, being creatures of darkness and gloom, would be at their weakest during this hour.

As THE SUN finally reached its highest point in the sky, Rama issued the order to attack. A deafening roar erupted from the charging vanaras and bears as they surged toward the hordes of demons, who responded in kind, blowing their horns and conchs. The rancor was terrible as the armies thundered toward each other.

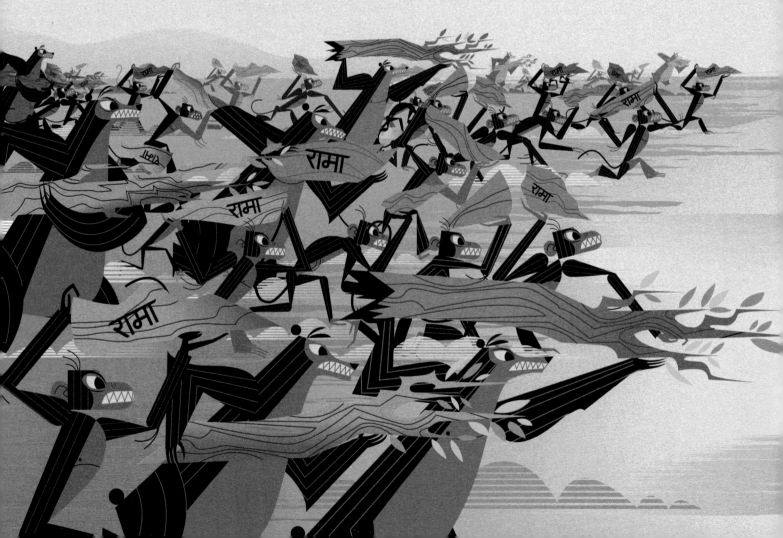

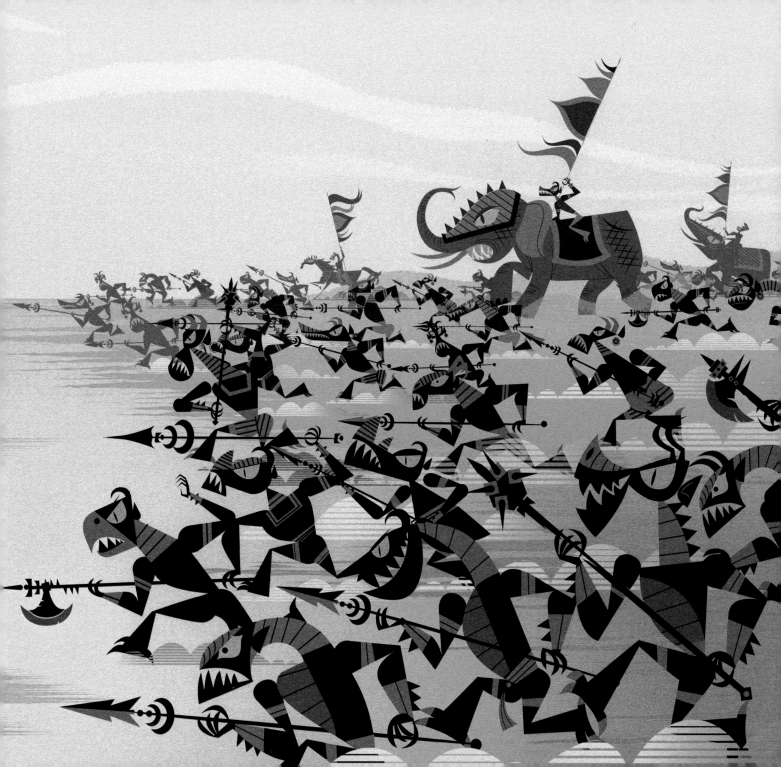

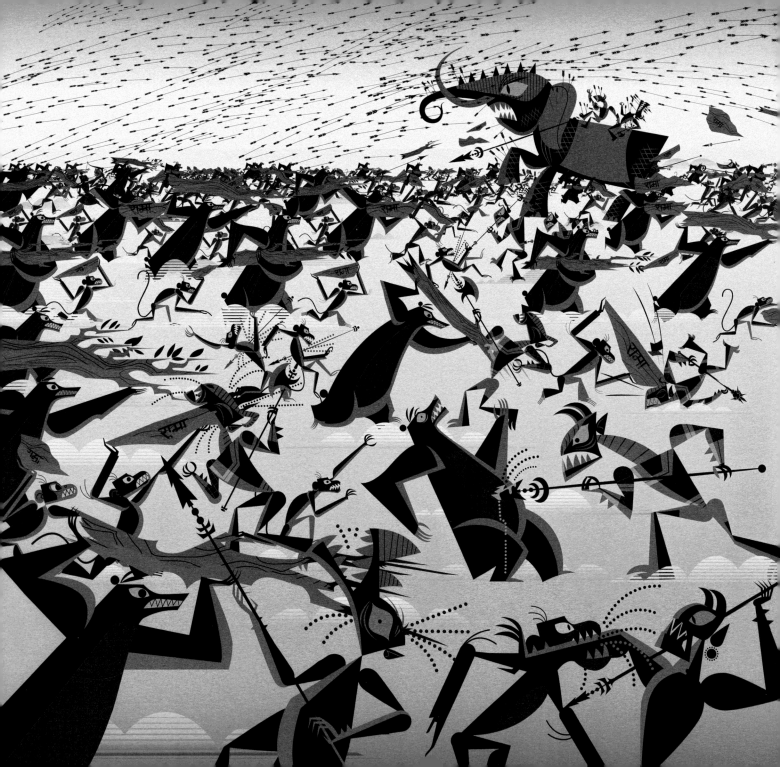

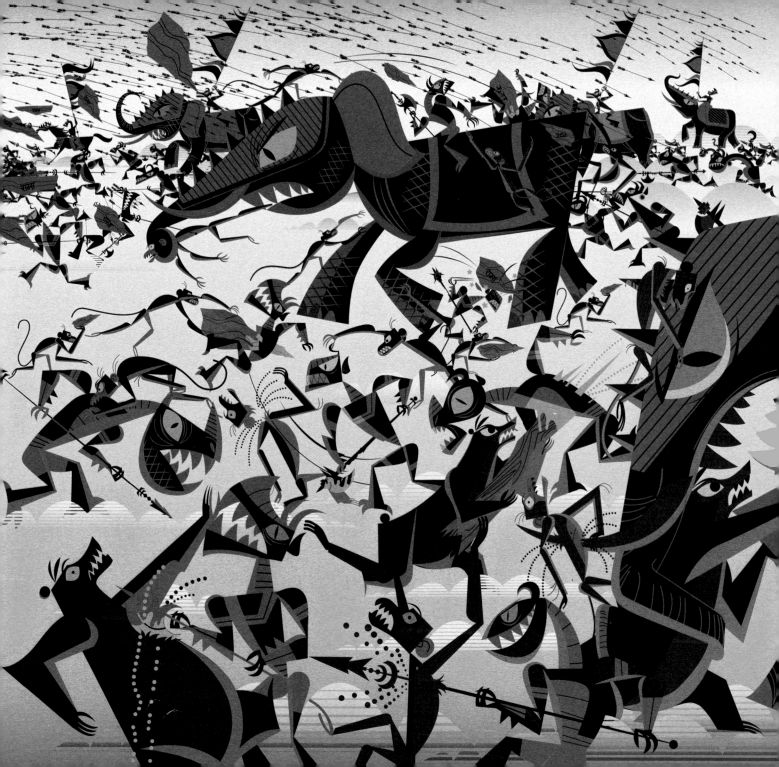

EVIL
ARROWS

BEFORE LONG IT became clear that the monkeys and bears were more than worthy opponents. The animals shattered, squashed, and ripped apart their enemies. Noticing their ranks dwindling far faster than they had ever seen, the demons turned to sorcery and began firing magic arrows that transformed into deadly snakes. The tide seemed to turn as Rama's warriors began dying by the hundreds. But then Lakshman picked up one of the snake arrows and fired it back at the demon army. As it shot through the air, it transformed into an eagle who screeched down upon the mass of snakes and began ripping the serpents to shreds. Soon the sky was filled with arrows-turned-eagles and the reptile menace was annihilated. Ravana's own sons, brother, and best generals led ferocious attacks against Rama's army, but one by one they were all defeated. The war seemed to be tipping in Rama's favor—until the demon king decided to take matters into his own hands.

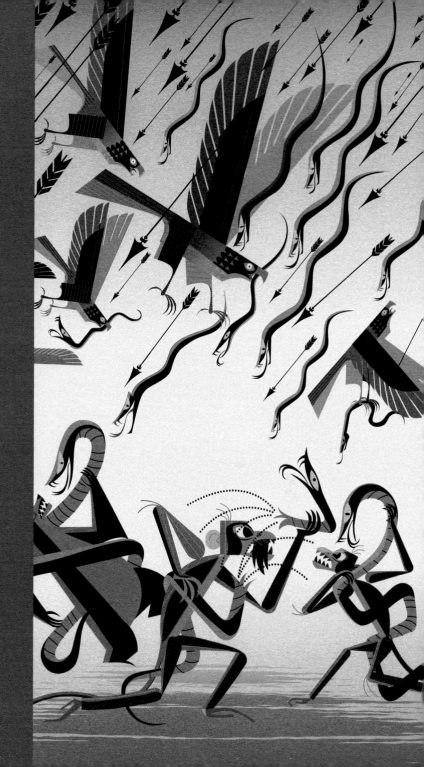

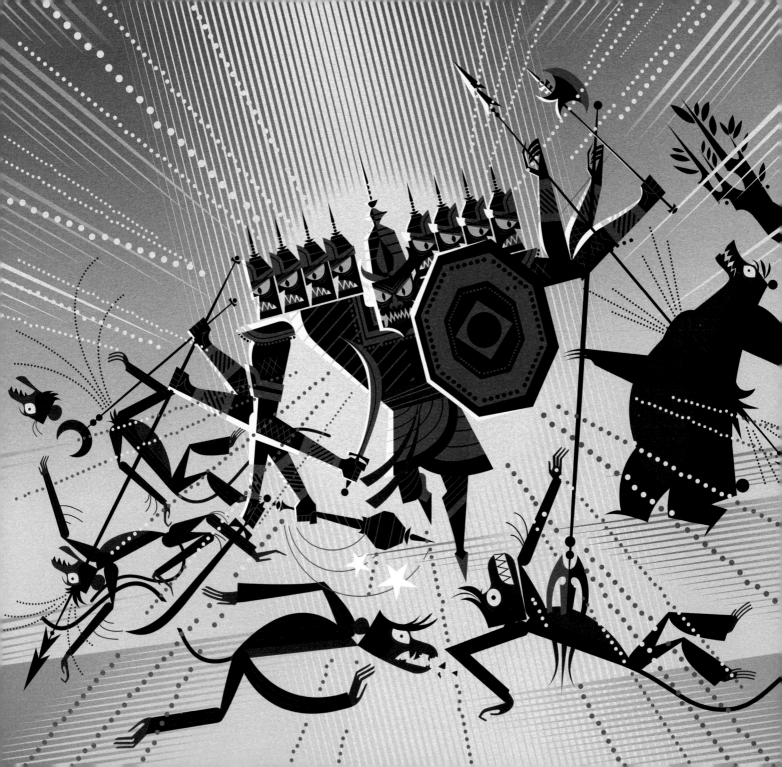

RAVANA'S RAMPAGE

AFTER WITNESSING THE destruction of his entire family, Ravana declared that he would enter the battle himself. The mighty ten-headed king could see and kill in every direction. Making his way through the battle, he felled thousands of monkeys and bears, sending a wave of fear through the jungle army. Sugriva and the other generals tried to counterattack, but the cruel demon continued on, striking down everything in his path. Even mighty Hanuman flew toward the demon king but was sent crashing down by a blazing volley of fiery arrows.

Ravana spotted Lakshman on the other side of the battlefield and charged straight toward him—he knew Lakshman's death would cause Rama great pain. Fast as lightning, the demon struck Lakshman with a single mighty blow. Rama watched as his brother fell. He immediately ordered his army to retreat as he whisked Lakshman off the battlefield. All of Ravana's heads smiled as he declared a quick victory.

Rama's generals rushed toward their fallen leader and began to cry and moan, for there was nothing the animals could do for the brave prince as he lay mortally wounded.

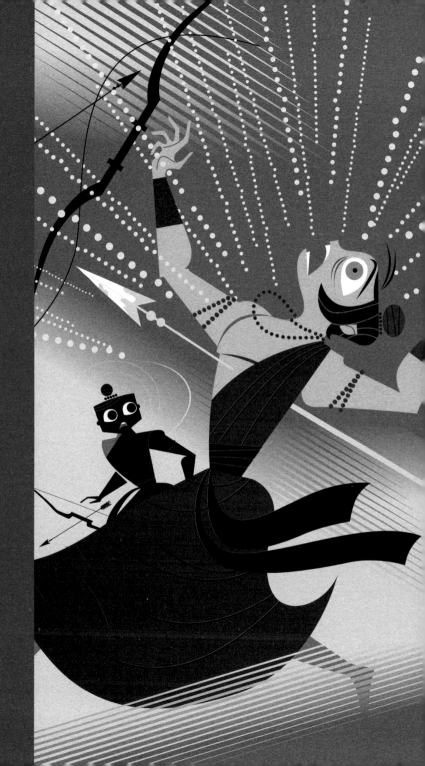

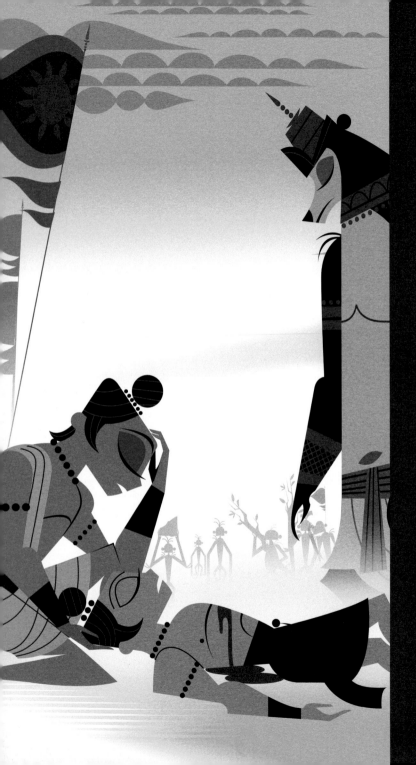

LEAF OF LIFE

RAMA LAID HIS hand on Lakshman's face and could feel his brother's life force leaving him. He despaired that the war was lost. Jambavan, ever wise, offered the one solution that might save him in time. Once again, he turned to Hanuman, son of the wind god, and called on his powers of speedy flight.

With no time to lose, Hanuman was dispatched. Swiftly, the monkey jumped across the ocean and the entire length of India, all the way to the Himalayas, where natural medicine grew. But upon reaching the mountains, Hanuman was confronted with a big surprise. There were plants everywhere. In fact, the whole mountain was covered with them. Hanuman was confused and didn't know which plant to pick. The sun was setting fast and Lakshman's time was running out. Hanuman began to shake and panic!

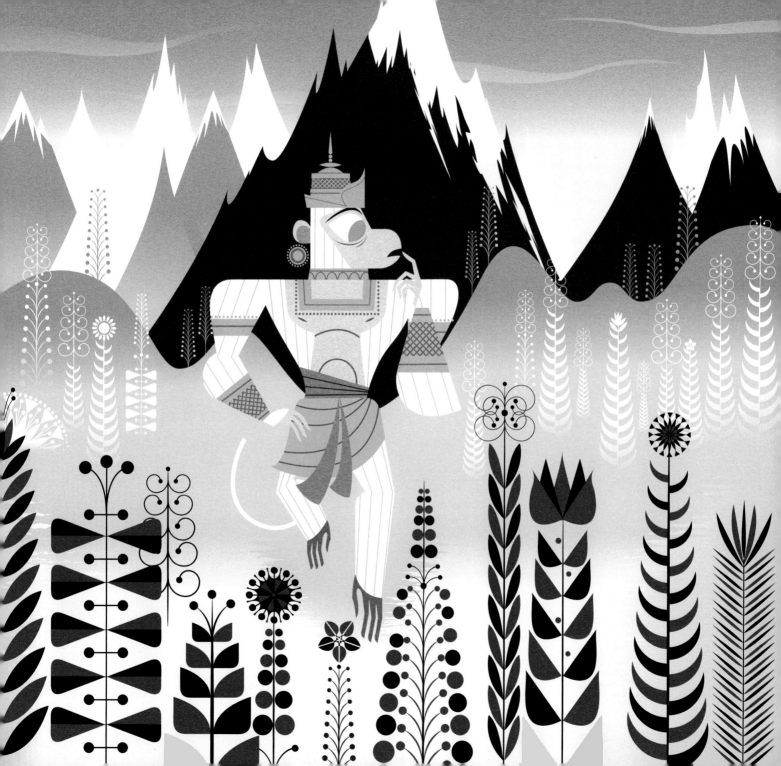

MOUNTAIN OF MEDICINE

HANUMAN PRAYED ONCE more by repeating the mantra of Rama's name. As he did, his body began to expand till once again he was as big as a giant. Ultimately, Hanuman did the only thing he could think of. In a cloud of snow and dirt, the massive vanara uprooted the entire mountain and balanced it in the palm of his hand. He shot across the sky, racing against time to return to Lakshman. The jungle army cheered as they saw clever Hanuman bringing back an entire mountain of medicine. Before the vanara could even land, a strong onshore wind blew toward Lanka and across the hillside of medicine, carrying the smell of the life-restoring herbs straight to Lakshman's nose. He revived, and when Hanuman landed, they wasted no time in gathering the herbs to restore him back to perfect health. Rama thanked the shrewd vanara and instructed him to harvest plenty of medicine before returning the mountain to its home.

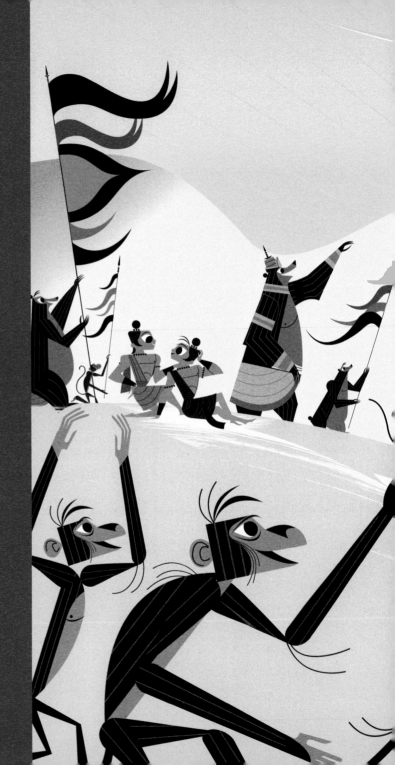

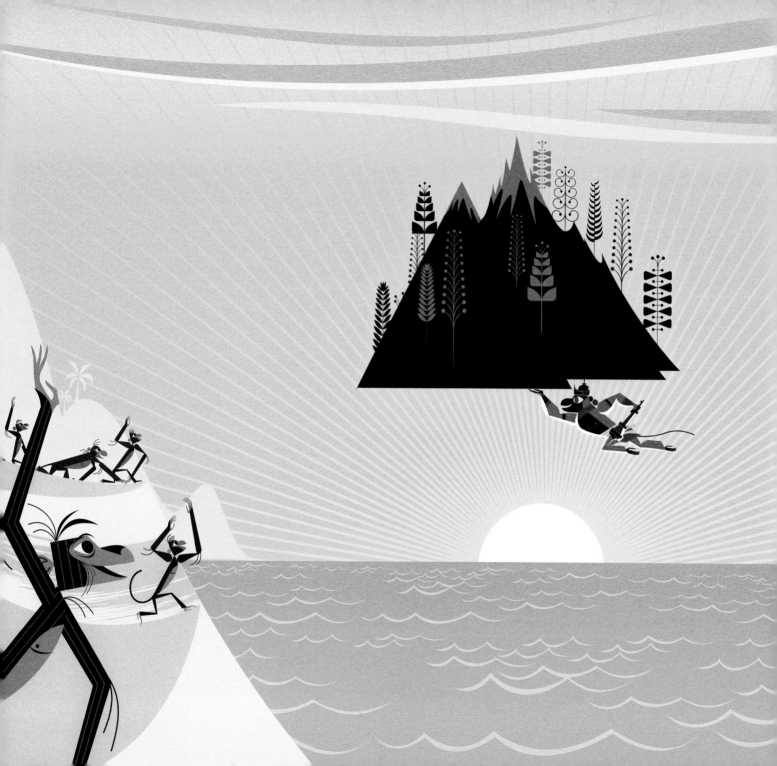

RAVANA WAS ASTONISHED to see Rama and Lakshman returning to the battlefield. The demon king was frustrated and annoyed that the war had not yet ended. He challenged Rama to a duel once the sun had risen.

At first light, the demon king of Lanka emerged proudly on the battlefield upon a mighty war chariot. Ravana shone as brightly as the sun itself, a truly magnificent warrior, and Rama realized that if the demon had not been his enemy, he would have been worthy of worship. But Rama knew that as magnificent as Ravana appeared, his crimes could not go unpunished. With great respect, Rama joined his palms and saluted the demon king with a fiery gaze. A hush fell upon the jungle army as Rama strode past the protection of his generals; Hanuman quickly intercepted him and insisted that Rama sit upon his furry shoulders so he could act as a chariot to ensure that the kings could have a fair duel.

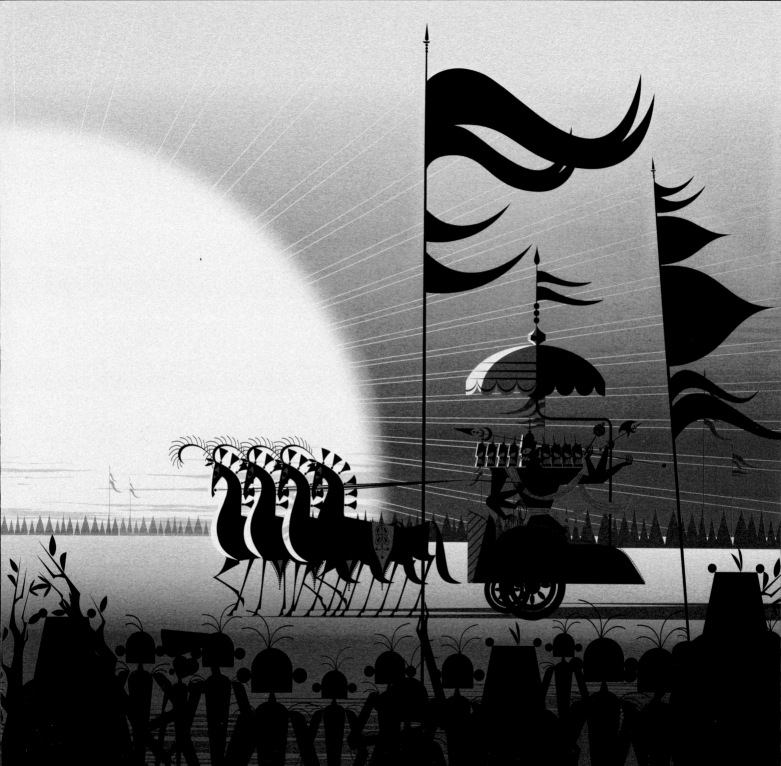

RAMA AND RAVANA saluted each other and faced off once more, and soon their weapons of war lit up the entire sky. The blue warrior struck down each weapon that Ravana fired until the demon was left with only one weapon in his twenty hands: Shiva's trishula, a three-pronged trident, with which Ravana could summon up the destructive flame of Shiva's third eye, a fire that could burn up the universe. Using all of his strength, the demon sent the trishula's flames leaping toward the warrior. Rama knew he would be incinerated by Shiva's fire, and so he turned to the magic arrow that had served him so well in the past. He called upon the arrow to become endowed with the *brahmastra*, a divine power with the ability to end all of creation, as it was wrought by the creator god Brahma himself. Rama fired the arrow a moment before the dark flames engulfed him. The earth shook as the two weapons collided. Equally powerful, the mighty weapons cancelled each other out, leaving the universe shaken but still in existence. As the dust settled, Rama saw that Ravana was drained of energy and unable to move. Seizing the opportunity, Rama quickly fired ten arrows, slicing off each of Ravana's heads.

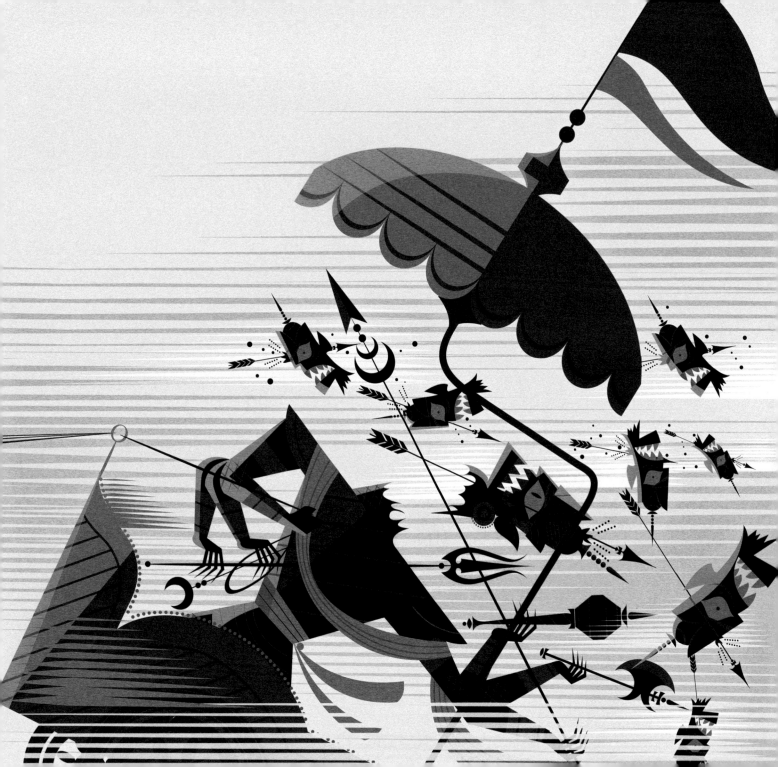

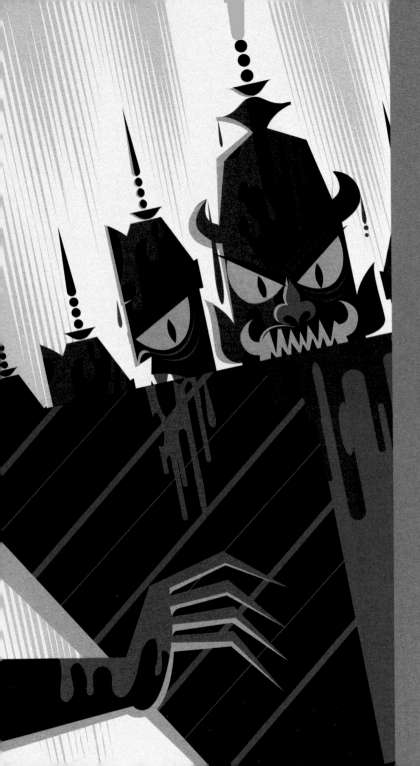

UNDYING DEMON

BUT INSTEAD OF dying, the demon simply grew more heads. Rama began to panic, shooting off several more heads, but they all quickly grew back. Hanuman did his best to dodge Ravana's attacks while the blue prince gathered himself. Over the demon's fiendish laughter, Rama heard the voice of Agastya, the sage he had encountered in the forest. The sage spoke in the prince's mind and reminded Rama that Ravana's heads could never be defeated, for they were an extension of his ego, which had no limits. Ravana had but one weakness, his belly button, which held the nectar of his power. Agastya suggested the prince quickly take aim at this vulnerable spot, for the demon grew stronger as each new head regenerated.

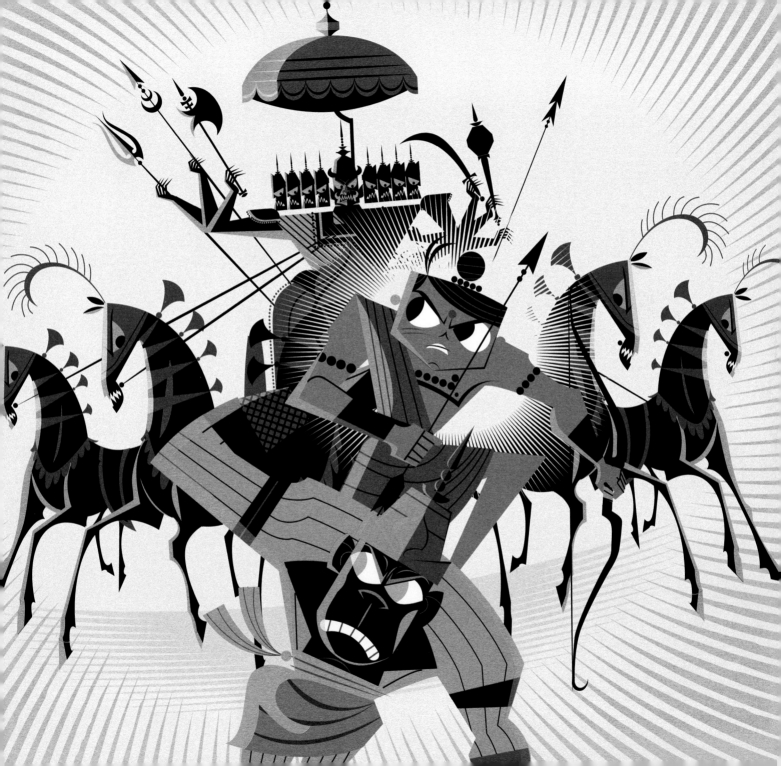

RAMA SUMMONED UP the brahmastra once again and charged the arrow with its power. The prince took careful aim and waited for the moment the demon was aligned with the sun before releasing the blazing missile. The arrow of light burned through the sky until it found its mark, striking Ravana directly in the belly button.

In a blinding flash, as the arrow struck its target, the demon saw the blue warrior's true identity as the avatar of Vishnu. Ravana realized that he had no protection from a god reborn as a man. This cosmic loophole brought swift justice. The golden arrow had flown with such force that it pushed Ravana's body from the earth, high up through all the levels of heaven and back down through to the lowest level of hell. The mystical arrow shined with such radiance that it extinguished the shadow of evil from every corner of the three worlds. The universe was silenced as evil was brought to an end for an age.

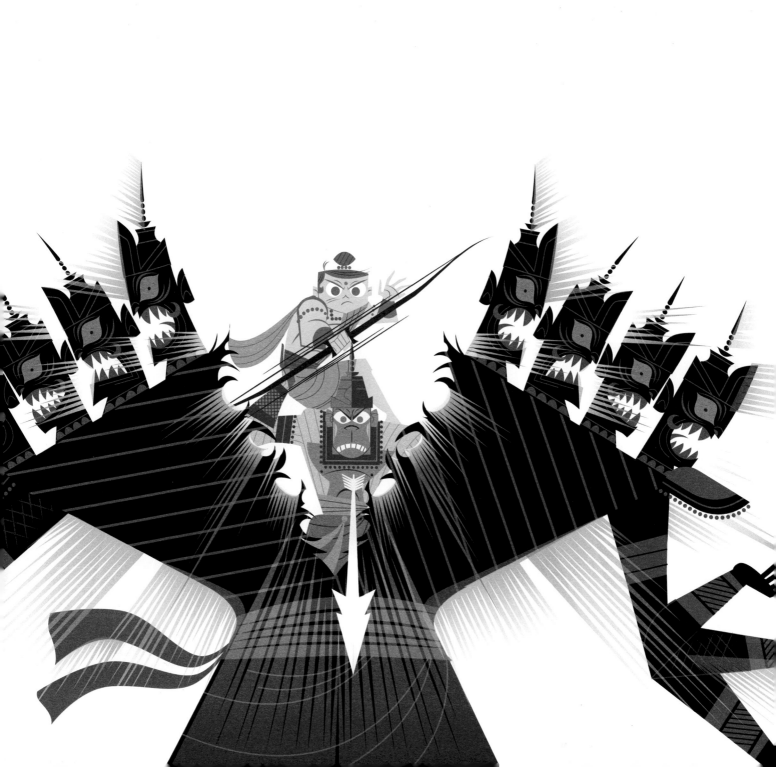

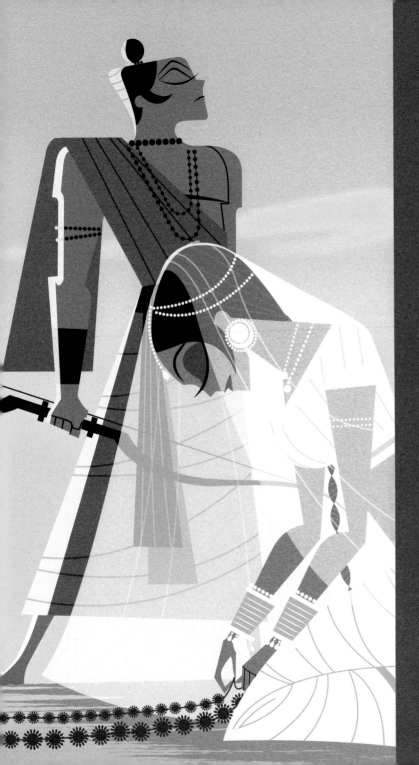

SITA'S HONOR

AFTER THE WAR was won, Sita was set free and restored with clean clothes and jewelry befitting her beauty. She was brought before her prince upon a royal palanquin. The entire jungle army stood breathless as the princess emerged and was escorted toward Rama. Sita presented Rama with a victory garland, but instead of hugs and kisses, Rama stared coldly at her and spoke with chilling words. The blue prince rejected Sita for having spent so many nights in another man's home. The princess felt so disgraced and heartbroken that she asked Lakshman to build her a cremation fire. Sita then spoke so everyone could hear. She declared that if she were innocent, she would be unharmed by the flames. Otherwise, she would gladly let herself perish before anyone who questioned her honor. Sita bravely walked into the fire and stood in its center.

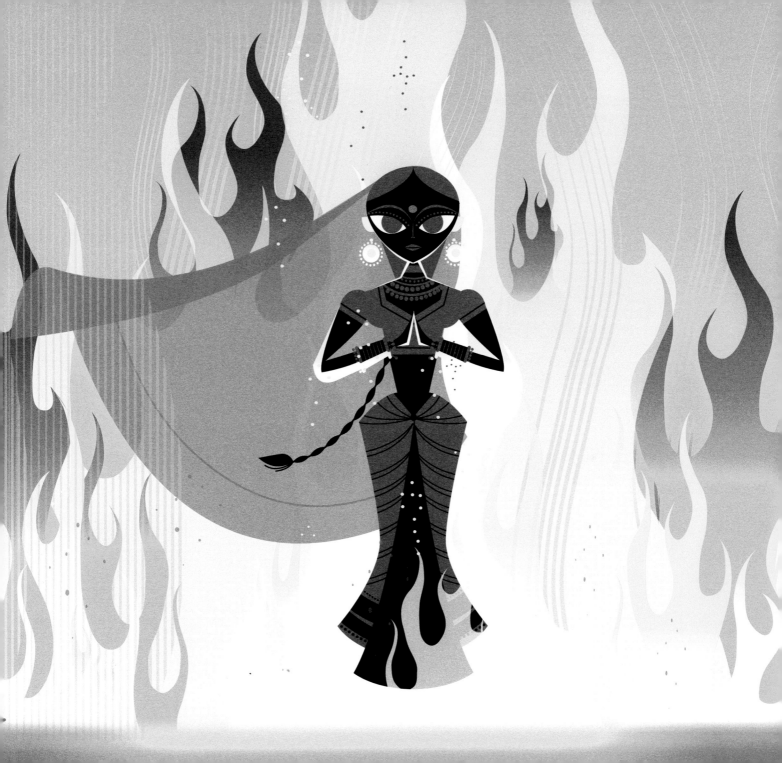

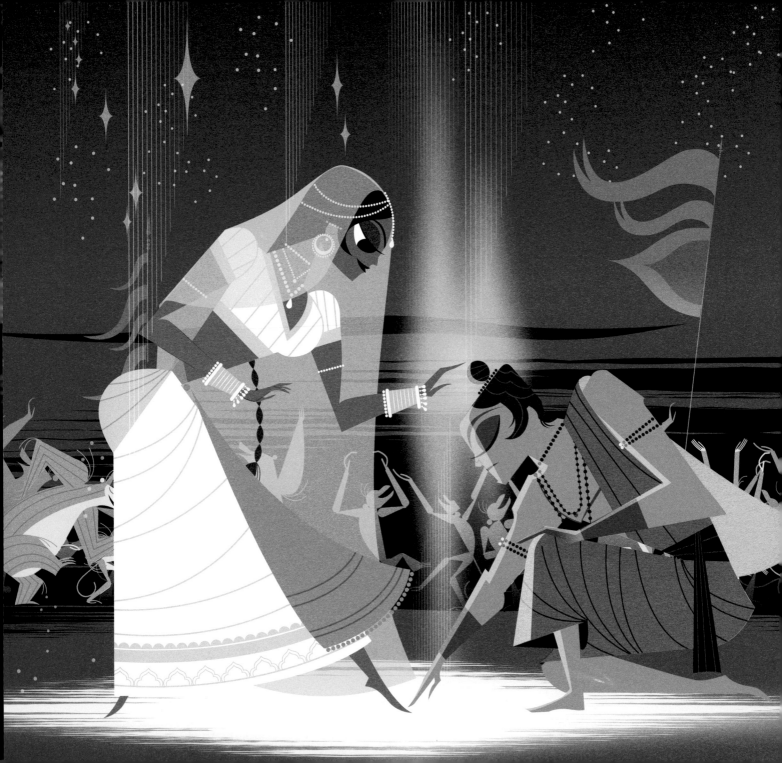

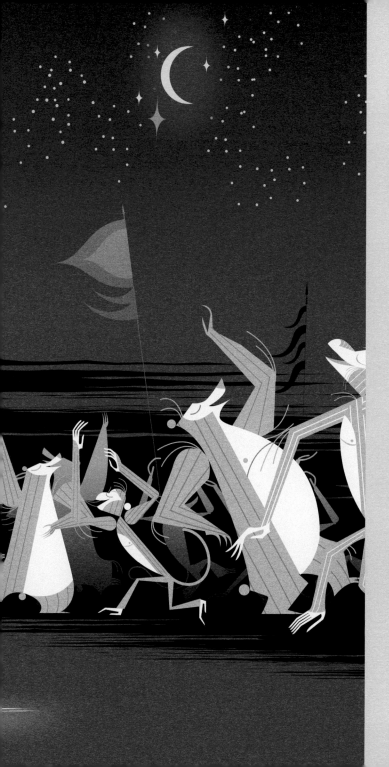

GLOWING GODDESS

SITA'S BODY BURNED with a golden, pure light, giving her the aura of a goddess. Then, Agni, the great fire god, emerged from the flames. The god explained to Rama that Sita was more pure than his own flame. She was faultless and perfect. Agni proclaimed that no doubt or question should ever be raised of her again. With this final word, the flames and the fire god were extinguished, and Sita was delivered back to Rama glowing radiantly as a jewel. Rama kneeled before Sita and apologized for his behavior. As he explained everything that he'd done to find her, Sita's heart softened and she forgave him. The two gazed at each other with an abundance of love as the crowd cheered.... *Times have changed, as have customs, but love has always been complicated.*

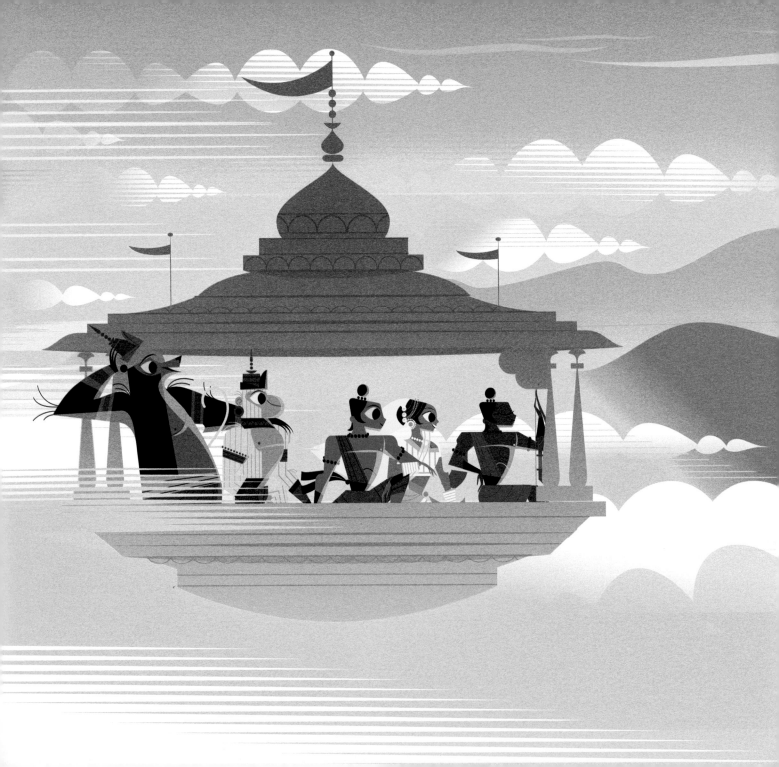

TIME
FLIES

WITH JUST A day left in their fourteen-year exile, Rama, Sita, and Lakshman were excited to go home. Rama bid farewell to his comrades and invited his loyal generals to join him. They all hopped aboard Ravana's chariot and quickly sped off from Lanka. From the vantage point high in the sky, Rama showed Sita the great bridge over the ocean and then the tall peaks of Kishkindha, home of the vanara tribes. Swiftly they passed over Panchavati, their home in the jungle, and over the Dandaka forest and past the hills of Chitrakoota. Before long they crossed over the banks of the Sarayu River. The chariot turned to follow the river's winding path, for Rama knew that its swift currents would lead them home.

As they crested the hills, a brilliant sight grew in the distance. Golden towers and gleaming domes rose majestically from the horizon, as they rapidly approached the mighty gates of Ayodhya. Rama and Sita were finally home.

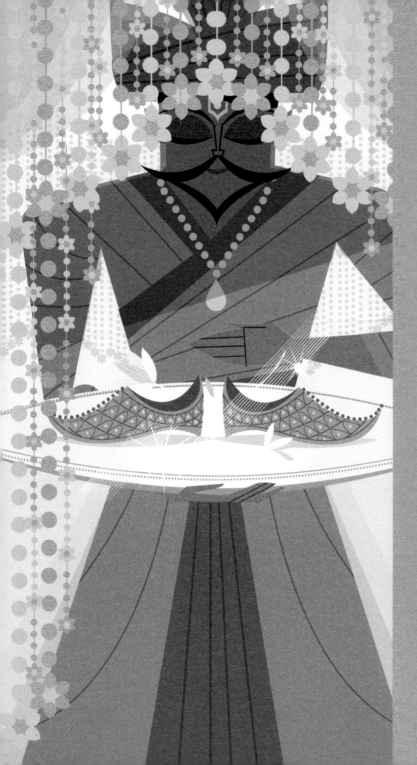

KING
AT LAST

AND SO IT was, on the anniversary of their fourteen years of exile, that Rama and Sita were both finally crowned the rightful king and queen. As Rama took up the throne, he saw the sandals that his brother had placed in his absence. Shatrughna and Bharata returned from their self-imposed exile and were honored to remove the shoes from the throne and place them back onto Rama's feet. With that gesture, the people rejoiced for the return of their king.

One by one, Rama called upon all of his loyal generals and explained to his court what each member had done to serve him during their grueling ordeal. After three months, it was time for his comrades to take their leave. Jambavan and Sugriva extended invitations to Rama, Lakshman, and Sita to visit their king-doms so that they could honor and welcome them as kings. When it came time for Hanuman to depart, Sita gave the vanara a very special gift: a necklace of her most cherished pearls. The vanara welled up with tears and swore an oath to Rama and Sita to always be their loyal devotee and humble servant.

And so began a reign of peace and prosperity that lasted longer than any other monarch's reign in India, known as "Ramarajya," the rule of King Rama.... *To this day much of India still celebrates Rama's return from exile and his victory over Ravana during the Hindu festival known as Diwali.*

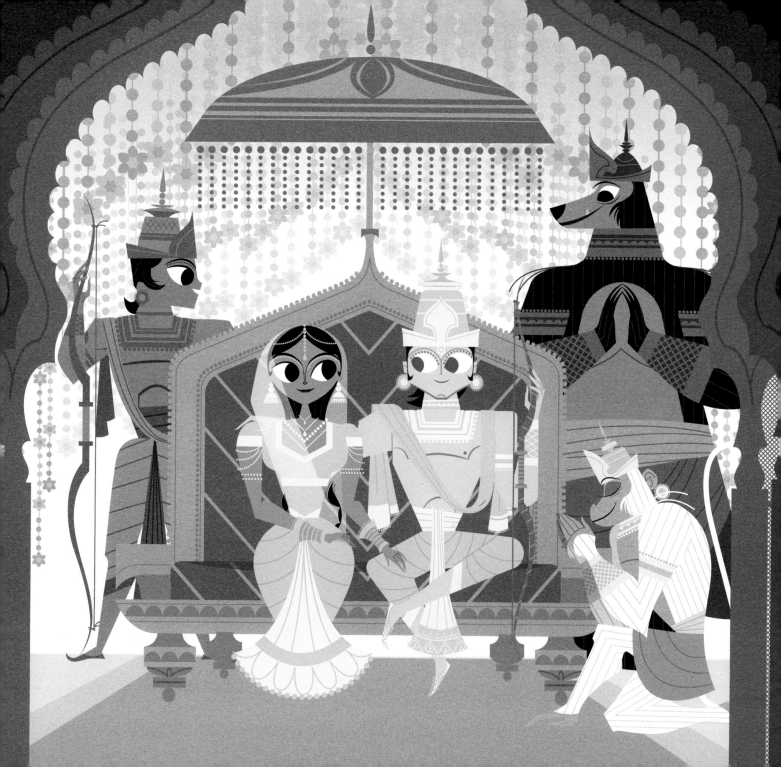

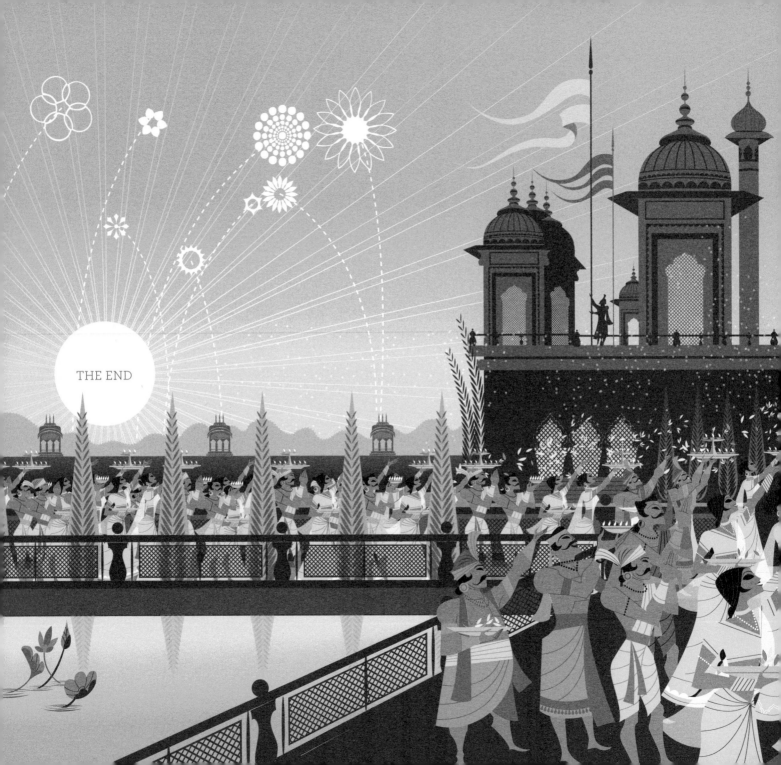

THE END

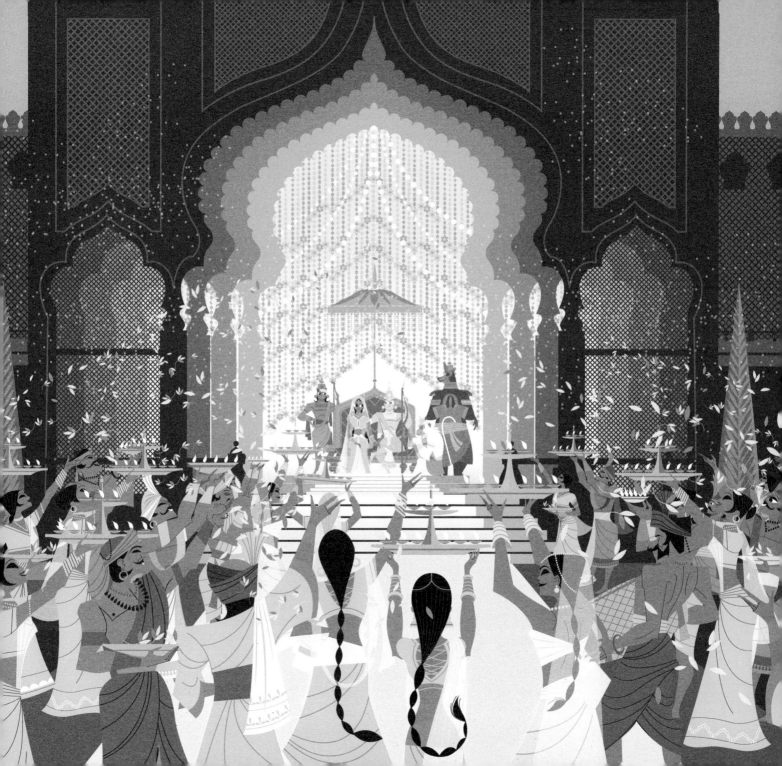

GODS & SAGES

DEVAS & RISHIS

The supreme god of justice and cosmic referee. Looking after the entire universe would be a big job if you weren't as handy as Vishnu. If one of his infinite hands isn't busy fixing something in the universe, he's probably listening to his people's prayers. In the Hindu trinity, which is made up of Brahma, Vishnu, and Shiva, Vishnu represents cosmic preservation. As such, the blue god of justice has ten avatars that appear through time to help preserve and uphold justice whenever it's threatened. Just like his plethora of hands, Vishnu has a thousand names, which are all auspicious words and symbols of his pervasive essence.

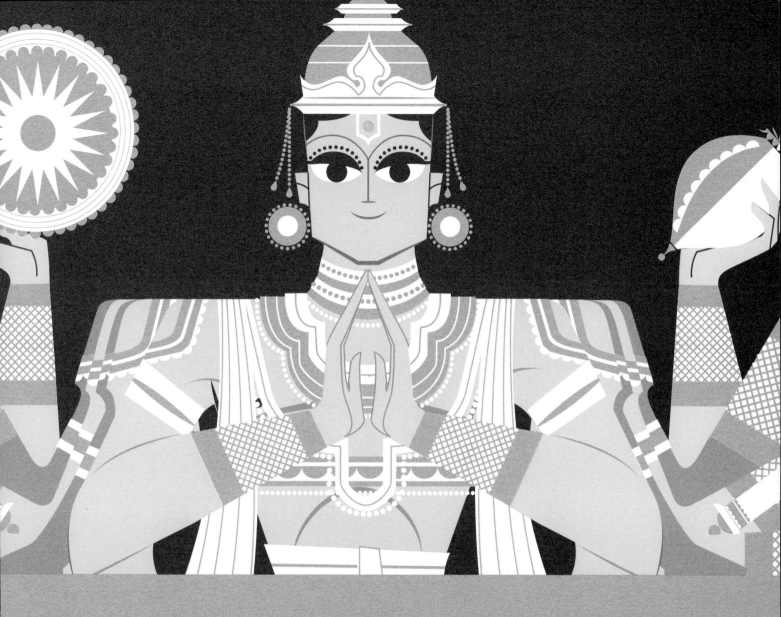

Vishnu
(vish-new)

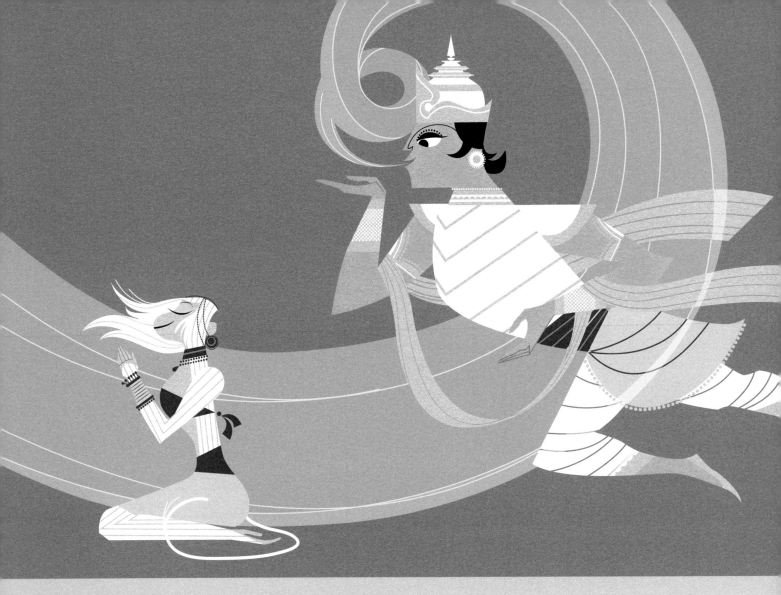

Vayu (vi-you)

The elemental god of wind and air. Despite Vayu's divine nature, he is no less driven by his lust and passion, which blows as far as his winds. The god sires many illegitimate children, but endows only one very special heir with his divine gifts. That child would be the loyal monkey Hanuman, which is why the vanara has the ability to fly. After Vayu catches sight of Hanuman's mother, Anjana, the wind god transforms her into a beautiful human for one night, and the product of their union is Hanuman, who eventually dwarfs his own father in his exploits.

Brahma (bruh-mah)

The four-faced creator deity is also part of the Hindu trinity. But unlike Shiva or Vishnu, who both have thousands of temples and millions of devotees, Brahma is virtually ignored. Blessing Ravana with his cosmic powers doesn't keep Brahma from being cursed with a lack of worship and reverence on Earth, nor does Brahma's behavior after he is finished with his finest creation, his own beautiful daughter. The deity begins lusting after her and sprouts five heads to always keep watch of her. That is, until Shiva gets wind of it and cuts off one of Brahma's five heads to keep the god under control.

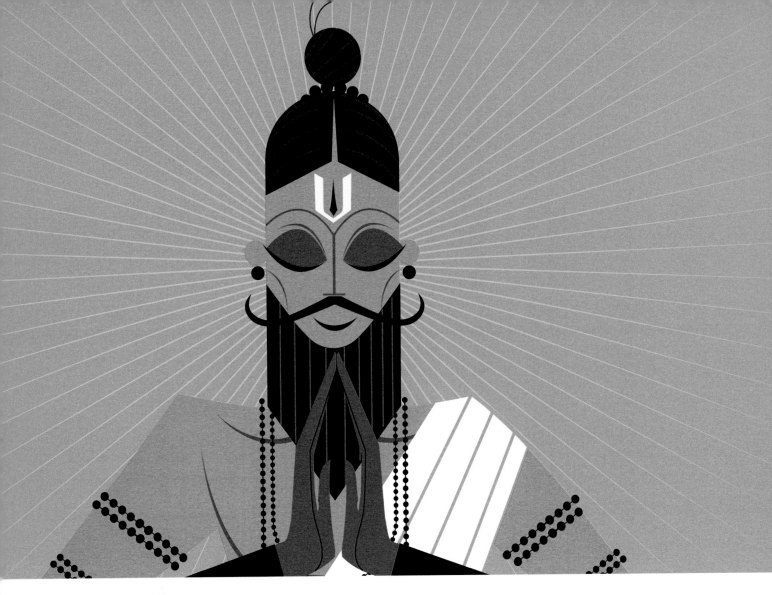

Vishvamitra (vish-vuh-mee-trah)

A brahmarshi (enlightened priest) and the spiritual guide of Rama and Lakshman. But Vishvamitra wasn't always so pious. He starts out as a war-faring king who curses and kills many to rise to the throne. But after a chance encounter and humbling fight with another guru named Vasishta over his mystical cow, Vishvamitra sees the error of his ways and retreats from society to perform penance. After enduring hundreds of years of austerity, Vishvamitra reaches the rare status of rishi. The creator god, Brahma, personally bestows the honor upon Vishvamitra and gives him a new mission. His assignment is to train the avatar Rama for his future ordeals. The kind rishi winds up recruiting both Rama and Lakshman and patiently teaches them all the wisdom he has acquired.

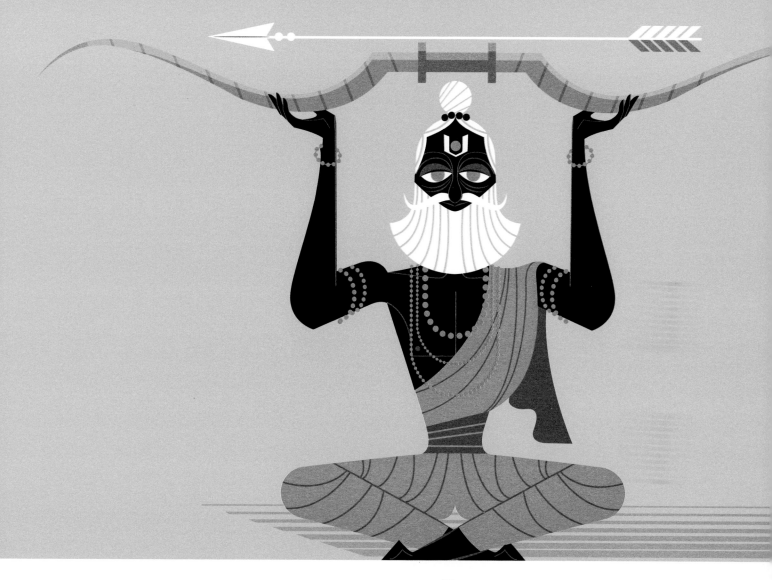

Agastya (e-gas-ta-ya)

The forest monk and sage who gives Rama the golden bow and arrow of Vishnu. According to legend, the sage politely asks a mountain range to lower itself so that he can relocate to the jungle of South India, because he knows the avatar of Vishnu will eventually pass that way. Agastya keeps the special weapons of Vishnu under his watchful eye and patiently awaits the day when Rama will cross his path. Upon finally meeting Rama, the sage instantly knows that the prince is the blue god reborn, and he is confident in giving Vishnu's bow and arrow back to their rightful owner.

WARRIORS

KSHATRIYAS

With a name like Dasaratha, which means "ten chariots," you have to be in charge of something. Dasaratha is the king of the warrior clan and rules over the kingdom of Kosola from the capital city of Ayodhya. He rules with three queens and four princes, one of whom is Rama. It sounds good being a king, but Dasaratha carries a heavy burden from a young age that eventually causes his death. After sending Rama into exile, the guilt-ridden king falls gravely ill and is bedridden. When he awakens, he remembers an episode from when he was hunting as a young man. When he was out in the forest, he heard a sound that he thought was his prey and immediately shot an arrow toward the noise. But he was mistaken, and the arrow had struck down a boy named Sharvan, the son of two blind parents. In their grief, the parents spoke a curse upon the king: that someday he too would suffer the fate of losing his dearest son. The memory of the curse brings Dasaratha's demise when he realizes that it has come to pass.

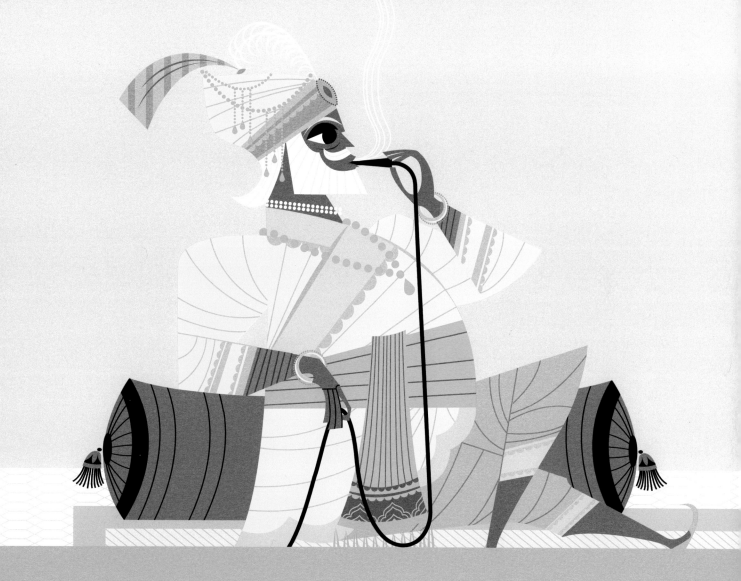

Dasaratha
(dah-sah-rah-tah)

Kausalya *(kow-sal-ya)*

The first queen and mother of Rama. So how does one give birth to an avatar of Vishnu? Well, according to legend, the gods delivered a fertility food to King Dasaratha. The king gave half of the nectar to the first queen, Kausalya, while the remaining half was divided between Sumitra and Kaikeyi. It's said that since Kausalya ate so much of the nectar, it was her destiny to give birth to Rama.

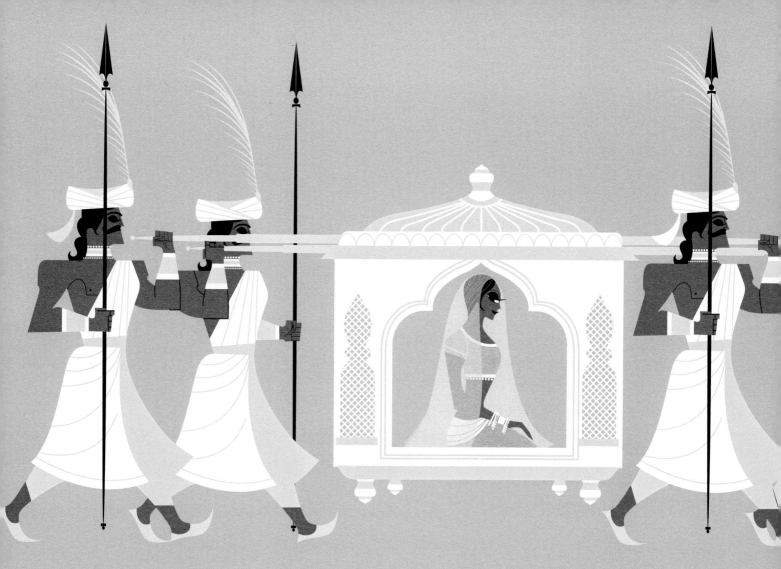

Sumitra (soo-mee-trah)

Third queen and mother of twin boys Lakshman and Shatrughna. The gentle queen is the picture of poise and grace and stands for service and charity. Accordingly, Sumitra raises both of her boys to be in service to Rama and Bharata, which is exactly what they do. When Lakshman decides to join Rama in exile, Sumitra is proud knowing that, if her son should die, he would do so in service to Rama.

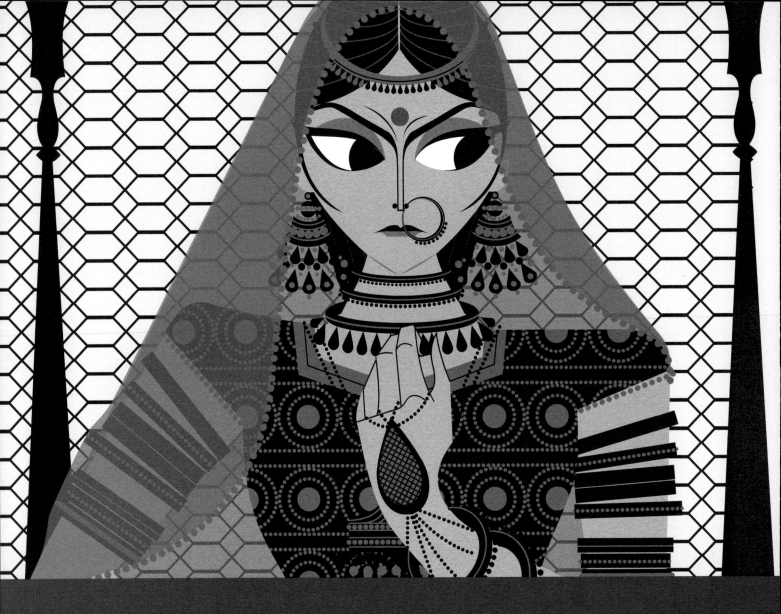

Kaikeyi
(ki-kay-yee)

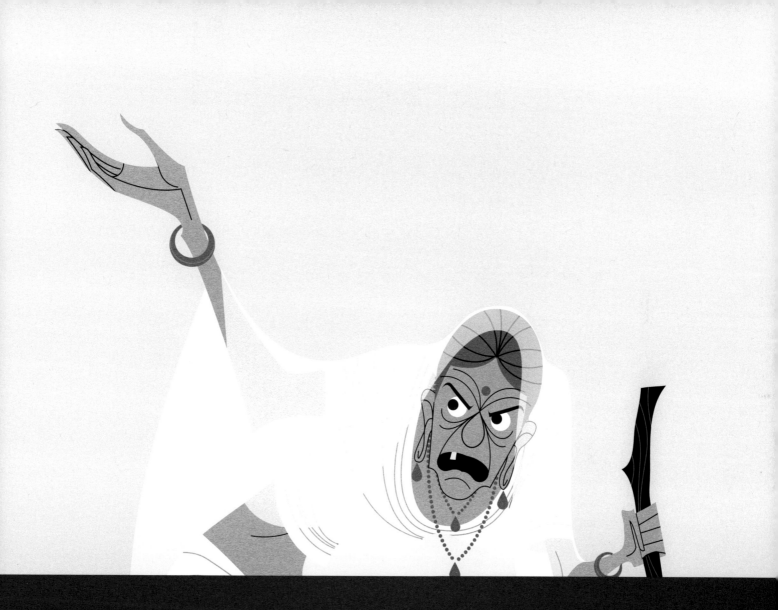

Kaikeyi is the hotheaded second queen, who banishes Rama to the jungle for fourteen years. But it isn't all Kaikeyi's fault. The queen has a hunchback servant named Manthra, who makes up a lot of nonsense about how Rama and the first queen will send the second queen packing once he is crowned. Kaikeyi falls for the soap opera and gives Rama the boot

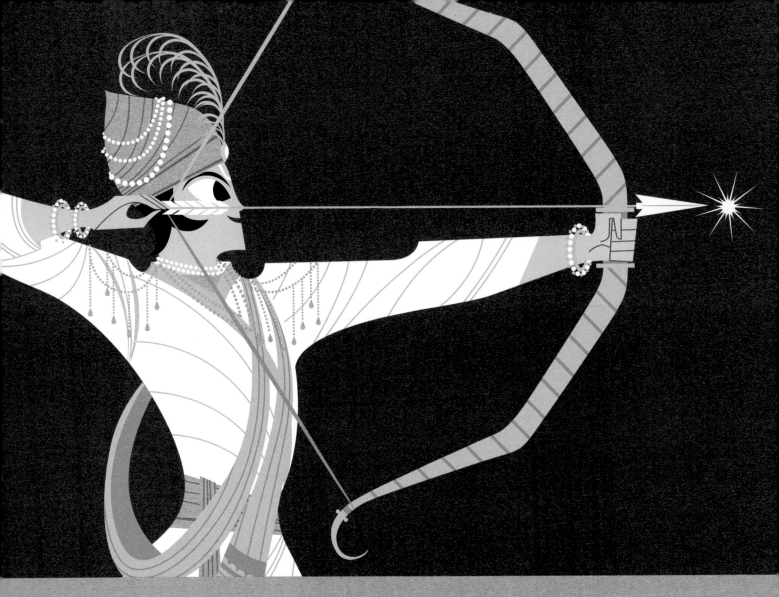

Rama *(rah-mah)*

The eldest prince of the captial city of Ayodhya and son of the first queen Kausalya. Since Rama is also Vishnu's seventh avatar, the prince is driven by a purpose higher than the desire to be a king. Rama's destiny is to rid the world of Ravana and his demon army. To fulfill this mission, the forces of fate conspire to send Rama directly into harm's way. But the blue prince proves time and time again that there is no obstacle that he can't overcome by simply following his divine mission and building bonds with the animals of the jungle. Vishnu's avatar is said to be the prefect man, so it's no surprise that Rama has been worshipped throughout India.

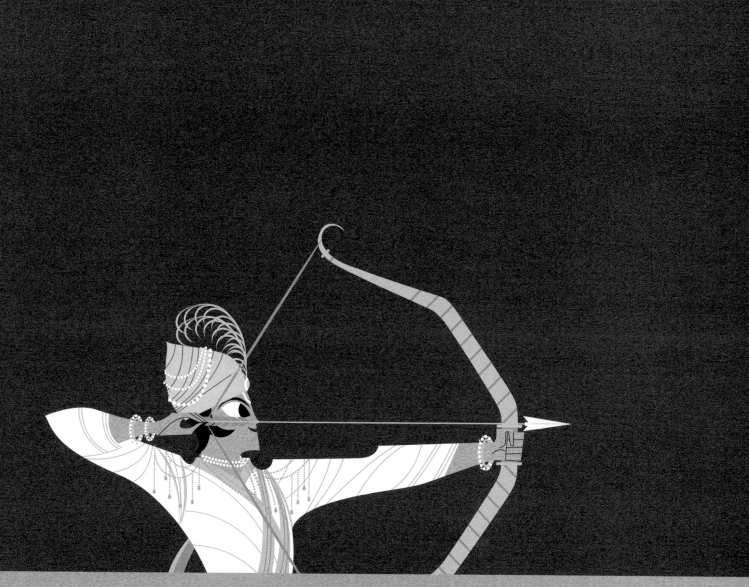

Lakshman *(luxsh-mun)*

Prince of Ayodhya kingdom and stepbrother of Rama. No matter what Rama is doing, Lakshman is at his side following his lead. Even after Rama is sentenced to exile, Lakshman can't bear to be separated from Rama and chooses to endure his brother's punishment along with him. At times a tad clingy, but extremely loyal, Lakshman will prove to be Rama's most important ally. The two brothers look alike, dress alike, and if Lakshman could have his way, he would probably dye his skin blue.

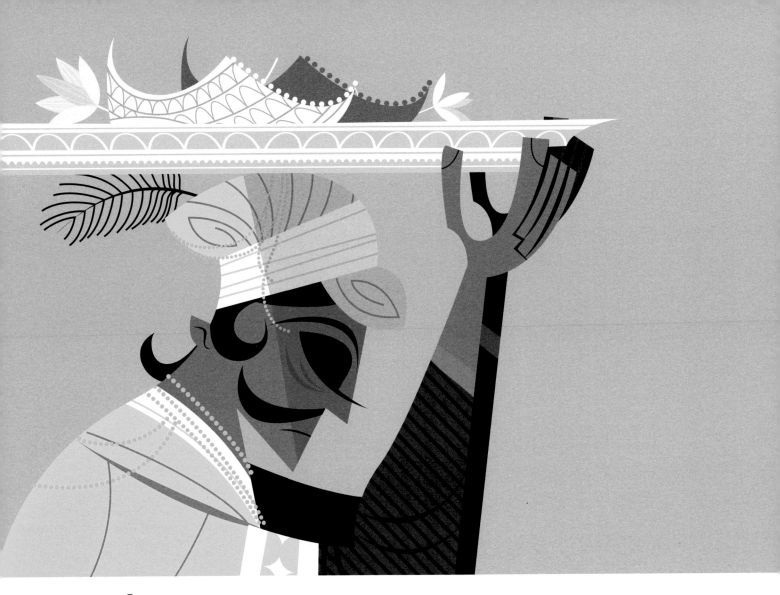

Bharata (bah-rah-tha)

Brother of Rama and son of second queen, Kaikeyi. Despite having a mom who exiled a god so her own kid could succeed, Bharata does his best to honor Rama by placing Rama's sandals on the throne to wait for the true king's return. He successfully rules as Rama's representative for fourteen years. He is so anxious for Rama to come back that he threatens to set himself on fire if Rama is even a day late! Luckily, the prince returns in time, and Bharata welcomes him in fine fashion. Rama intends to make Lakshman his Crown Prince once he becomes king, but seeing Bharata's devotion, he changes his mind and gives it to him instead. Bharata is seen as a man of unparalleled virtue and devotion.

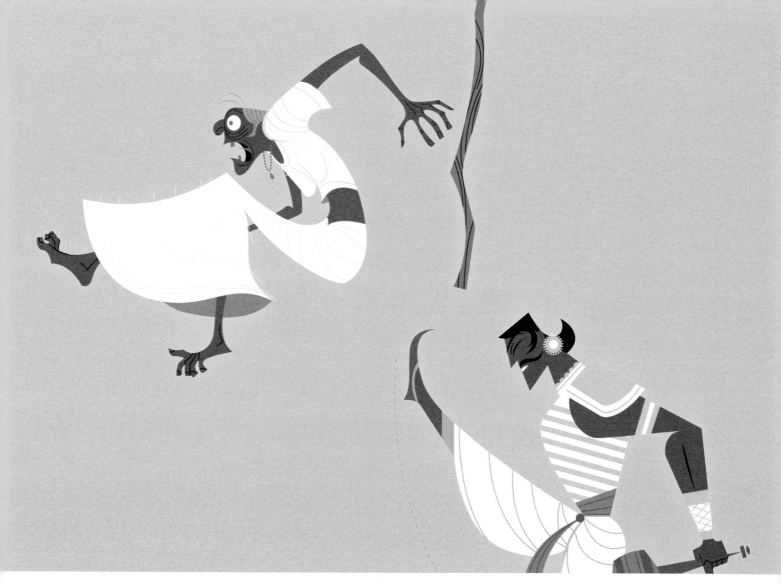

Shatrughna (sa-troog-nah)

Prince of Ayodhya and son of the third queen, Sumitra. Since his twin brother Lakshman has more in common with Rama than with him, Shatrughna finds affinity with his stepbrother Bharata. The two brothers love clobbering each other with their swords and maces. One time, the prince even manages to clobber Manthra, Kaikeyi's servant, after learning that she was spreading gossip.

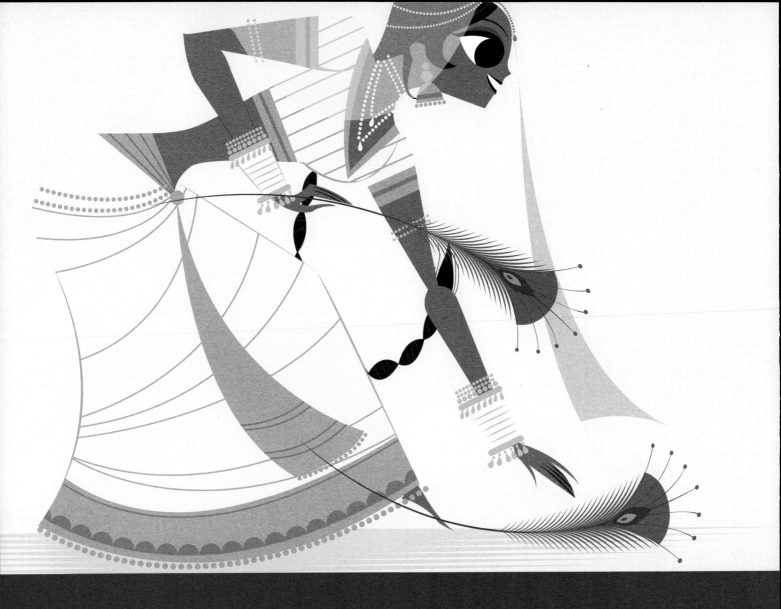

Sita
(see-tha)

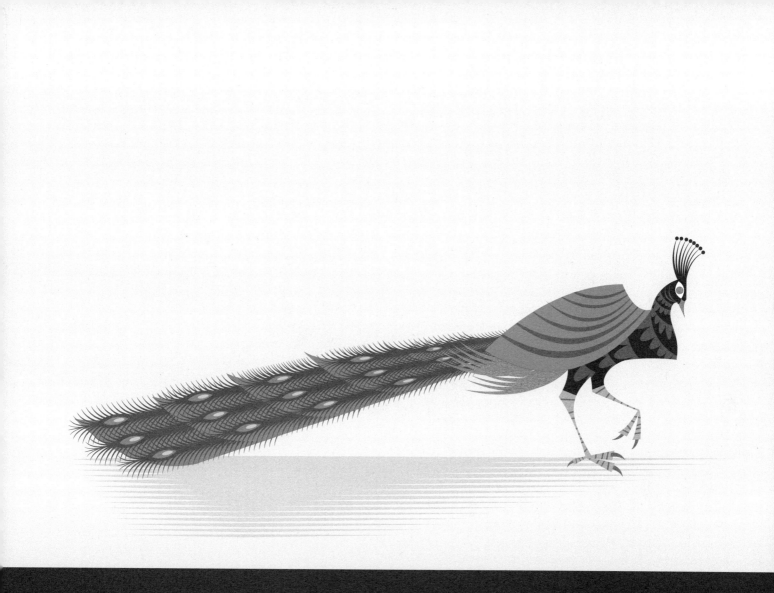

Daughter of King Janak and wife of Rama. According to legend, Sita literally popped up out of a plowed field and caught the king's eye. The Earth child is thought to be an avatara of the goddess Lakshmi, who is Vishnu's eternal sweetheart. I guess it makes sense that if Vishnu's going to be reborn as Rama, he is going to have his wife take the form of Sita. But despite her origins, the princess is both blessed and cursed with divine beauty, as it's her radiance that draws both Rama and Ravana to their great war.

ANIMALS

PRANI

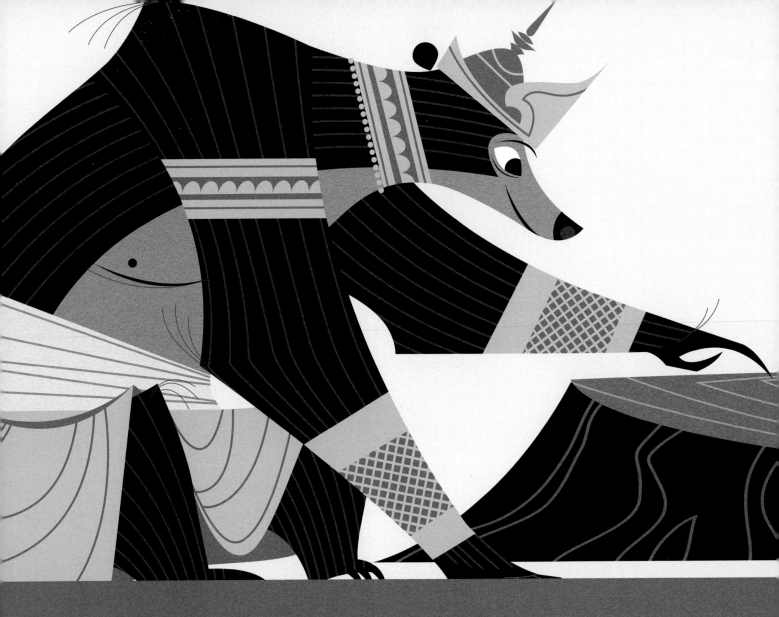

Jambavan

(jum-ba-van)

The great bear chief and wise elder. It's been said that the old bear is one of the first animals created by the god Brahma. The ancient bear knows a lot of history, which comes in handy, especially when he and Hanuman are looking for Sita and get stumped trying to find a way to cross the ocean. Jambavan reminds Hanuman of his powers so that the monkey can fly to the island where Sita is being held captive.

A guardian eagle that protects Sita from Ravana. The eagle chief is delighted to look after Rama and his family, since the great bird once fought side by side with Rama's father, King Dasaratha. After learning of the king's untimely death, Jatayu adopts Rama and

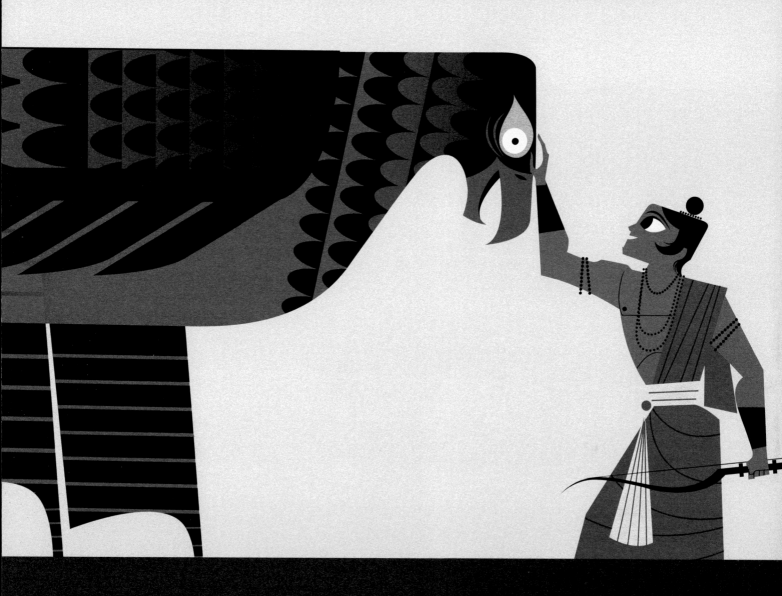

Jatayu

(jut-tiy-you)

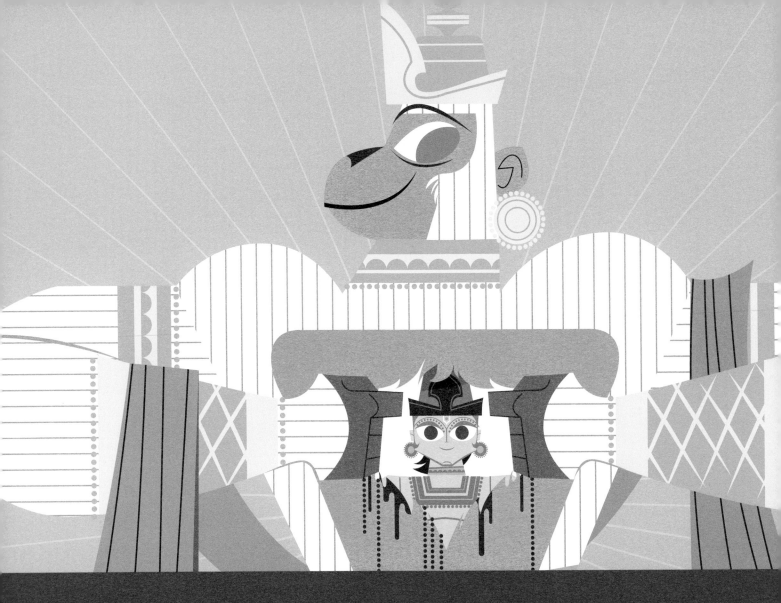

Hanuman

(ha-noo-man)

Sugriva's general and one of Prince Rama's closest allies. This superstrong flying monkey is the child of the wind god, Vayu, and could just as easily tie you in knots as he could launch you into outer space. The fierce champion of Rama is so devoted to the blue prince that he even rips open his own chest to prove that Rama's image is glowing in his heart.

Exiled king of the monkey tribe and ally of Rama. The regal monkey has his share of family turmoil, mainly because of his older brother, Vali, the first monkey chief. After Vali chases a demon into a cave and doesn't return for a year, the crown passes down to Sugriva, who rules fairly. Vali returns suddenly one day, furious with his brother for stealing his crown. He attacks him with no mercy. Sugriva flees for his life and lives in exile with his general, Hanuman. Luckily, the monkeys happen to befriend Rama, who agrees to set things straight with Vali. Upon meeting the menacing brother, Rama has no choice but to strike the creature down with a deadly arrow. Thus, Sugriva owes a great debt of gratitude to Prince Rama, who in turn earns the allegiance of the entire monkey tribe.

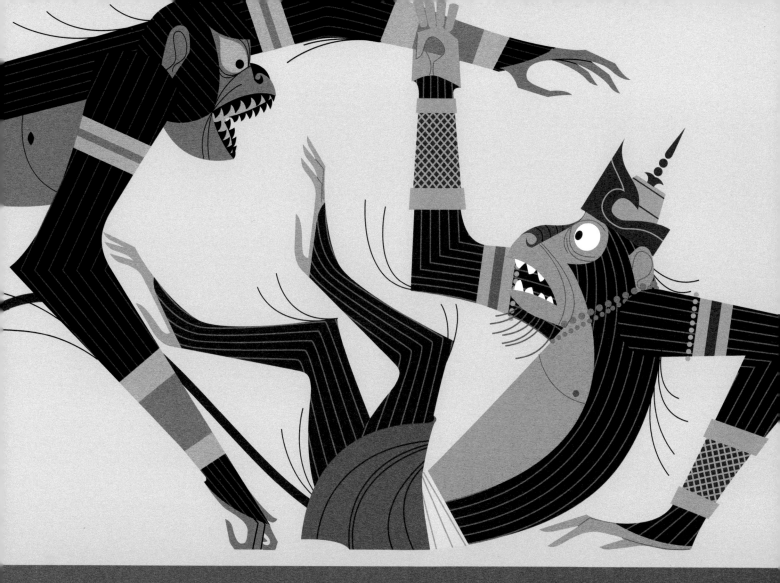

Sugriva
(soo-gree-vah)

DEMONS

RAKSHASAS

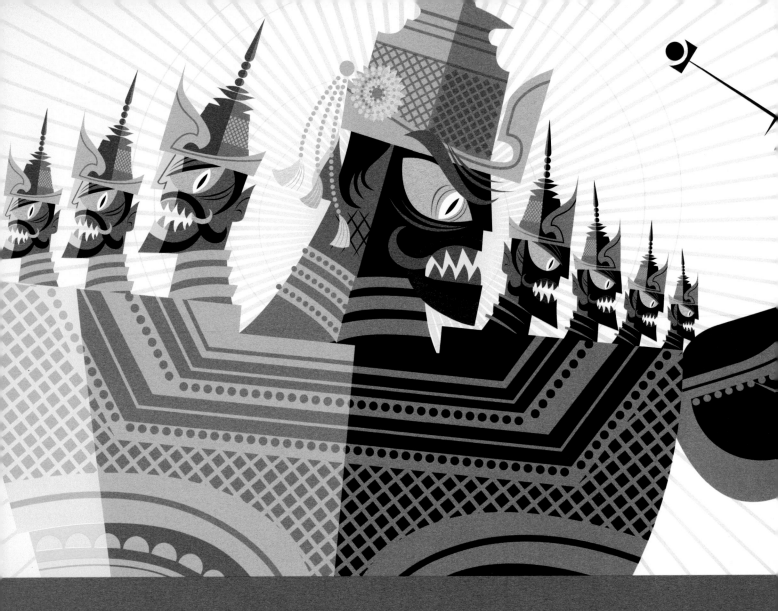

Ravana
(rav-vun-nah)

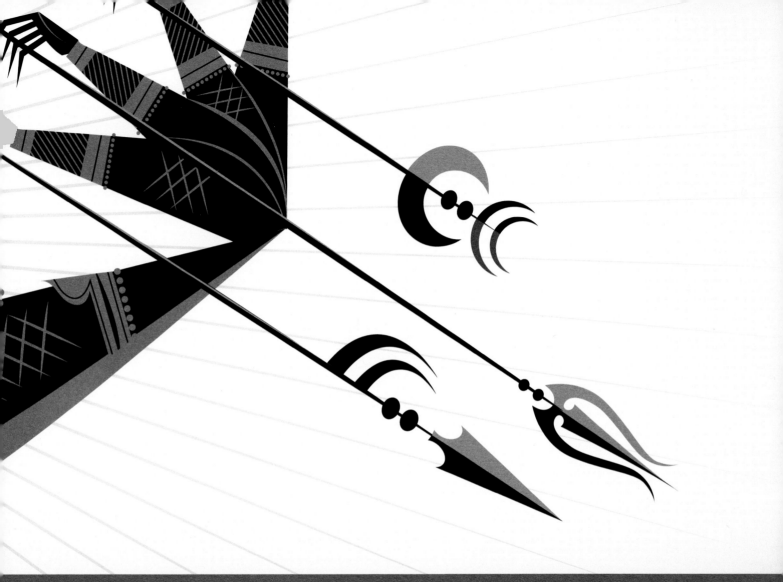

The king of demons, with multiple heads and arms—a symbol of both his great intellect and ego. Since Ravana is the child of a wise priest and demon mother, he possesses both good and bad qualities. The unique combination gives Ravana the wisdom and cunning to get pretty much anything he wants. Once, the demon even manages to escape certain doom by singing a song that melts the god Shiva's heart. Surprising victories like this earn the demon great respect and power, but they also bring out his demonic ambitions to rule everything in the universe. It isn't long before Ravana is committing terrible crimes that overshadow his intelligent nature.

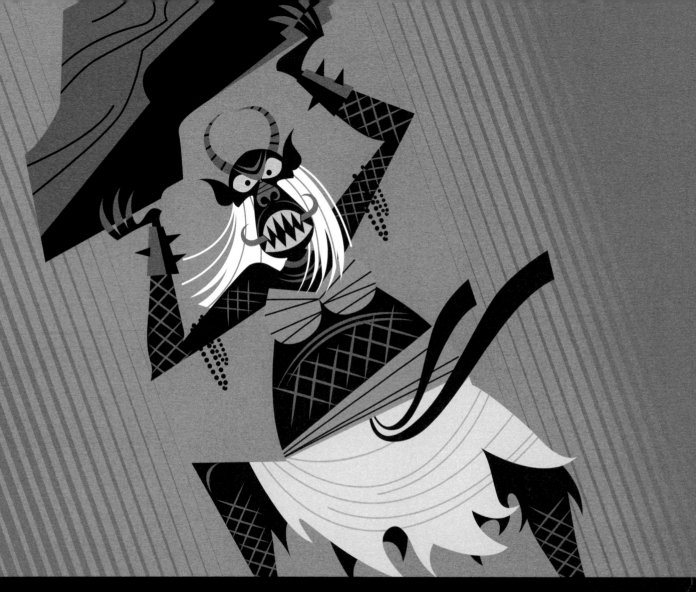

Tataka (tah-tah-kah)

A giant demon who is vanquished for disturbing the rishi Vishvamitra's holy rituals. Even before she became a demon, this woman was built like a mountain, with the strength of one hundred elephants. And, boy, the ground shakes when she learns that her husband has died. Tataka loses her marbles, goes on a rampage, and is cursed to become a demon since she was behaving like one anyway. From then on, she pretty much makes life hell for everyone, especially the priests and gurus who had cursed her. Since the holymen

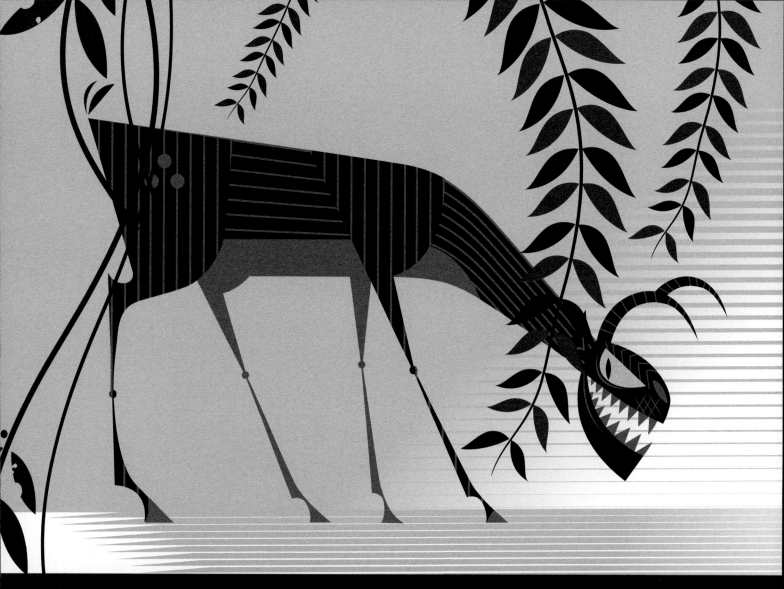

Maricha *(mur-ich-ah)*

A revengeful uncle of Ravana who transforms into a golden deer to lure Sita into a trap. This demon has a deep grudge against Rama, especially after Rama shoots him with an arrow and sends him clear across India to live on a remote island. And if that isn't enough, the demon later learns that Rama has slain his mother, Tataka, during his training mission. The angry demon finally exacts

The demon sister of Ravana who falls in love with Rama. Love can be complicated, but sometimes it can be downright dangerous, especially when a bloodthirsty demon wants to give you a smooch. And even though this demon can transform into a beautiful maiden, she isn't fooling anybody, especially happily-married Rama. The moment Soorpanaka spots Sita, things get pretty ugly. It turns out that the only thing worse than turning down a demon is making her jealous.

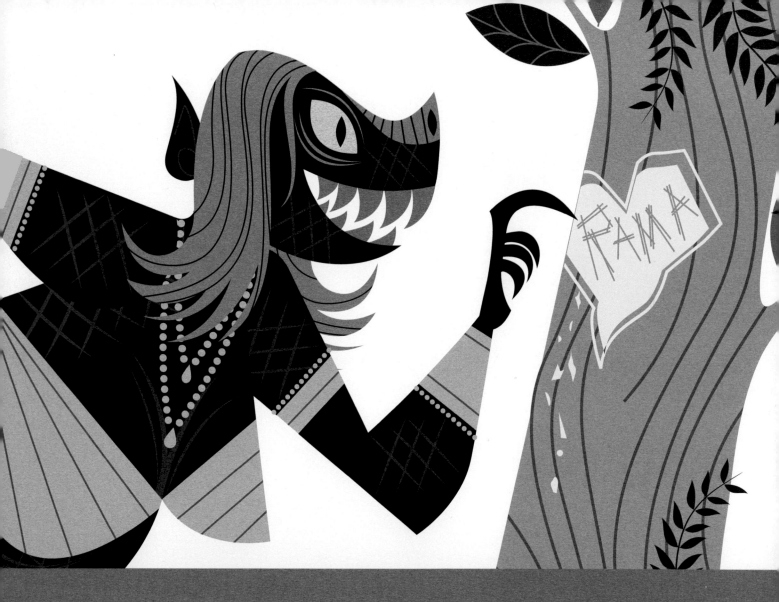

Soorpanaka
(soor-pah-nah-kah)

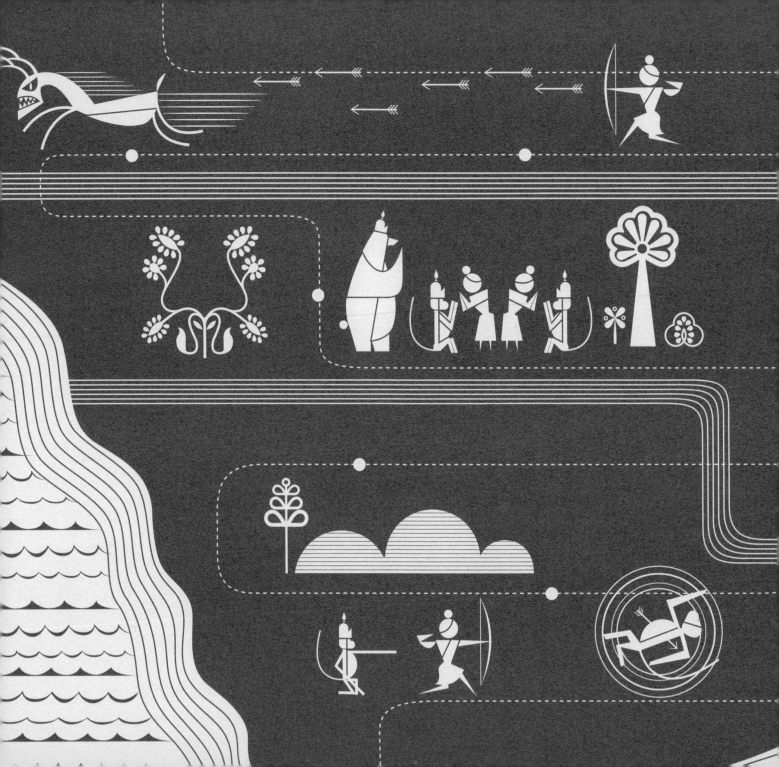

GEOGRAPHY

The Route of Rama

INDIA

1. AYODHYA: Capital city
of the warrior kingdom.

5. DANDAKA: A demon-infested forest.

2. MITHILA: Sister city to Ayodhya where Rama breaks the bow of Shiva and ties the knot with Sita.

4. AGASTYA'S ASHRAM: Sacred forest where Rama meets the hermit colony.

3. CHITRAKOOTA: Forest where Bharata finds Rama and takes his sandals.

6. PANCHAVATI: The hills where Ravana springs his surprise attack and abducts Sita.

7. RISHYAMUKHA HILL:
Hill where Rama and Lakshman meet Sugriva and Hanuman living in exile.

8. KISHKINDHA: The kingdom of the monkey tribe where Rama slays Vali.

9. MALAYA HILLS:
Hills where Jambavan and Hanuman search for Sita.

10. THE GREAT BRIDGE OF RAMA:
A bridge of floating stones constructed from mainland India to present-day Sri Lanka.

SOUTH
INDIA

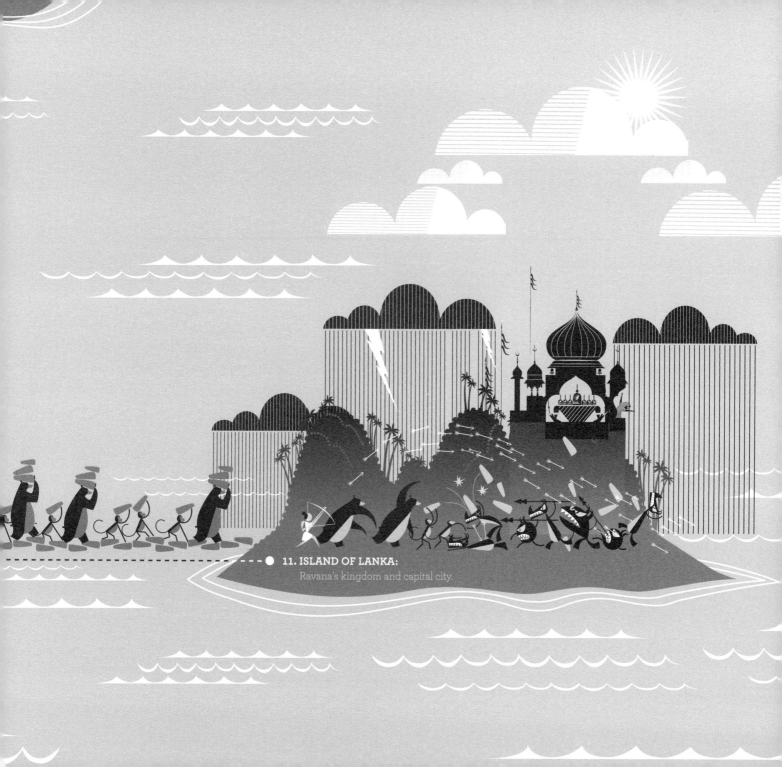

11. ISLAND OF LANKA:
Ravana's kingdom and capital city.

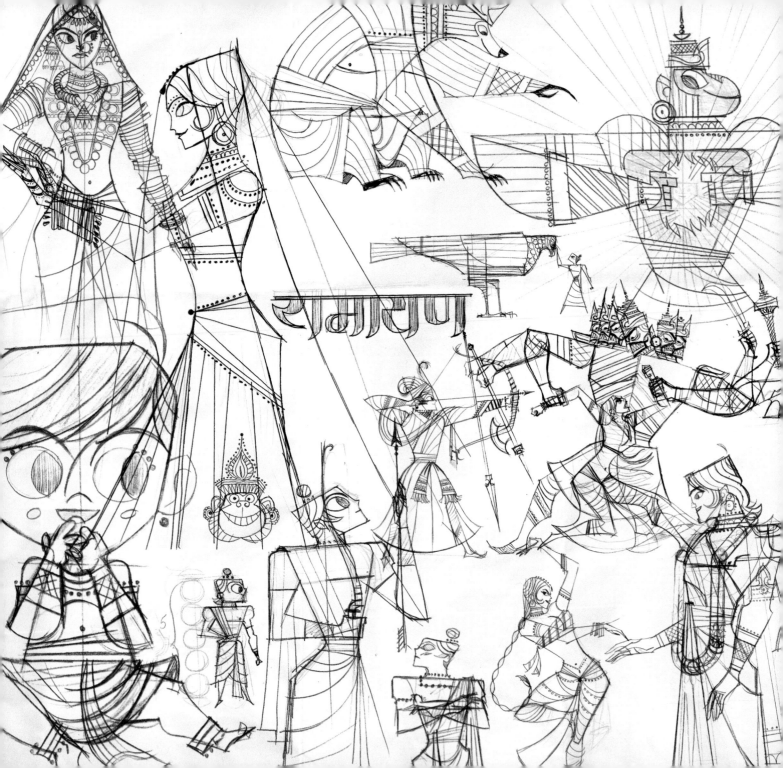

रामायण

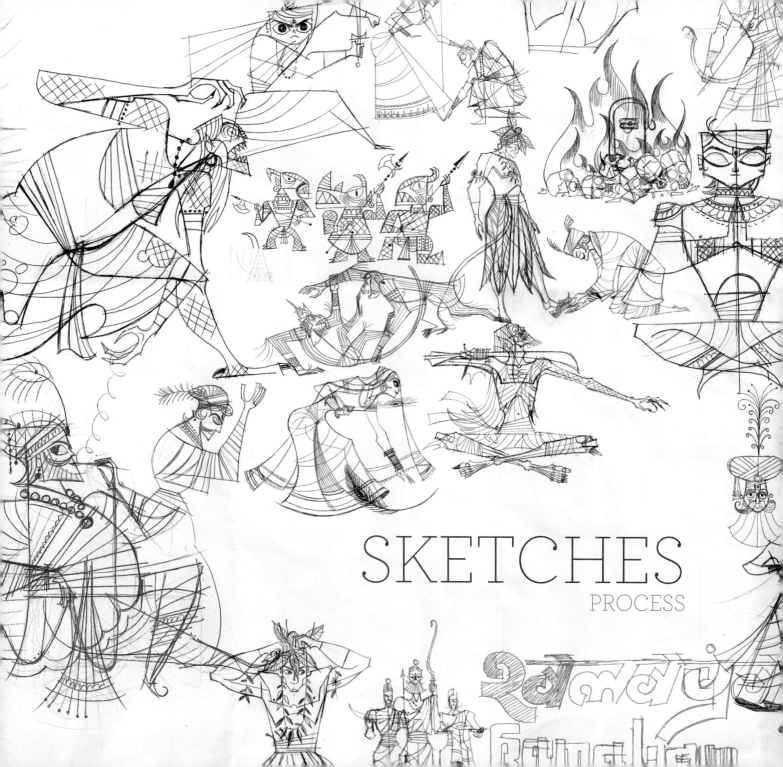

SKETCHES

PROCESS

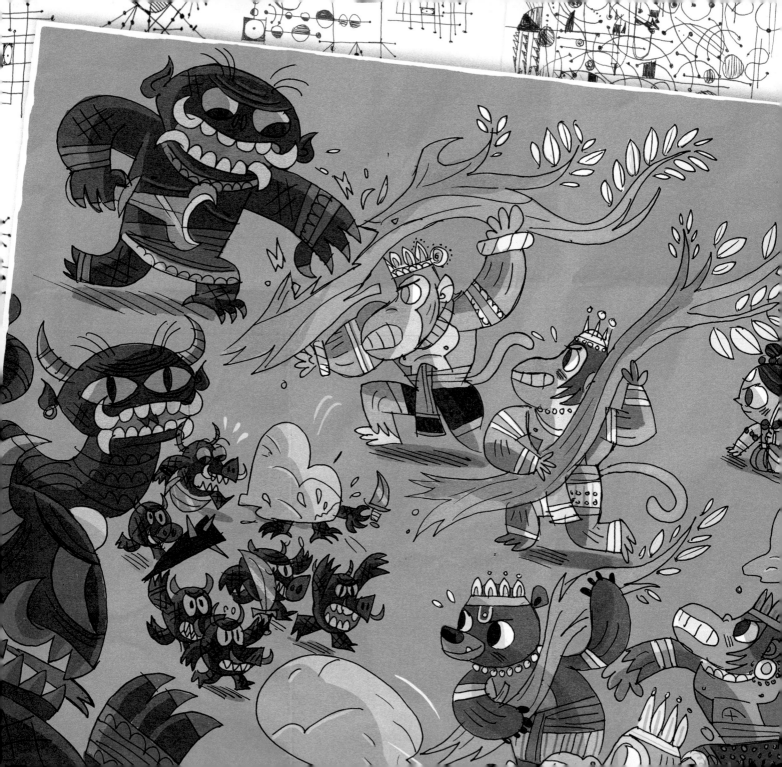

DRAW, DRAW, AND DRAW SOME MORE.

There is no magic or mystery to any of this; it's all about drawing and re-drawing. Even before I began to write, I was inspired to just sit down and make one drawing and then two and so on, and so on...

Sketching is just another way of thinking and another form of writing. As I sketch, I try to first communicate the story point as clearly as possible. Once I feel confident that the symbols and icons are telling the story on a visual level, I start considering compositions and layouts. I do hundreds of mini rectangles that represent the two pages of the book and work with the largest shapes to arrange them in the most dynamic way. From there, I enlarge the thumbnail composition to a full pencil illustration, usually on a regular sheet of blank paper. In this enlarged sketch, I carefully work out all the shapes and details as tightly as possible. Eventually, this sketch becomes the blueprint for my computer illustration.

I use a scanner to import my sketch into the computer and use it as a template. Then, I use a program called Adobe Illustrator to carefully plot out vector points to recreate the shapes I sketched. Once the shapes are built to precision, I can fill them with any color I choose and adjust the spectrum with ease.

From start to finish, this book took approximately four years to make, or roughly seven days per page. There are no shortcuts. The truth is, if you love scratching away on paper and organizing marks to make symbols that tell stories, you wouldn't want it any other way. Keep drawing; the art will reveal itself. It's inevitable; just trust the process.

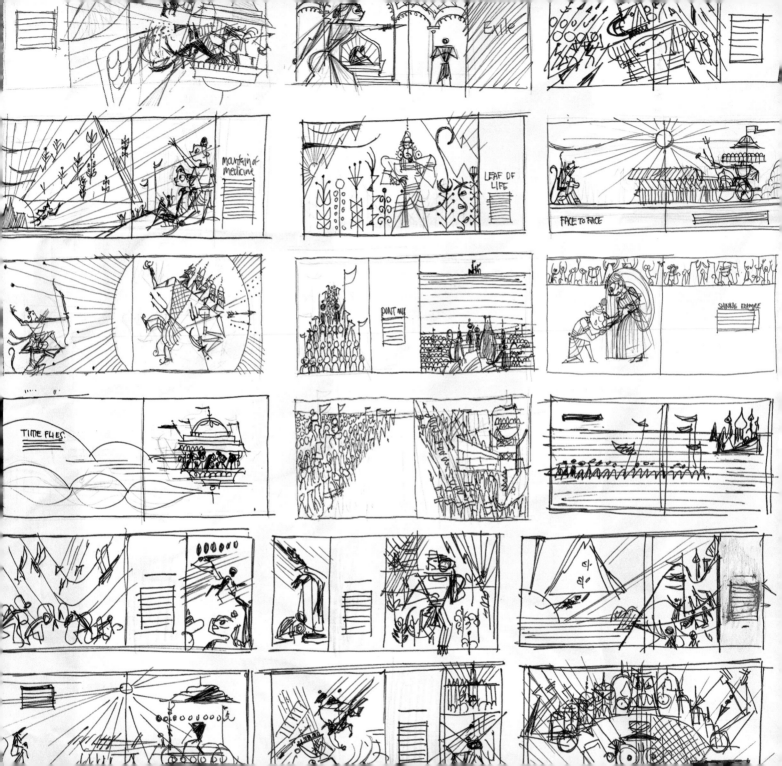

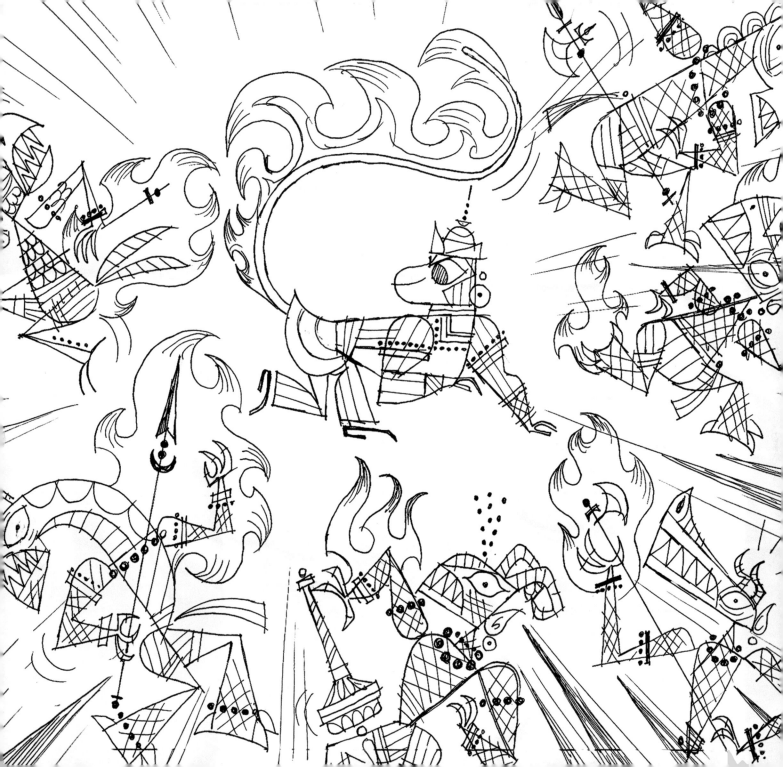

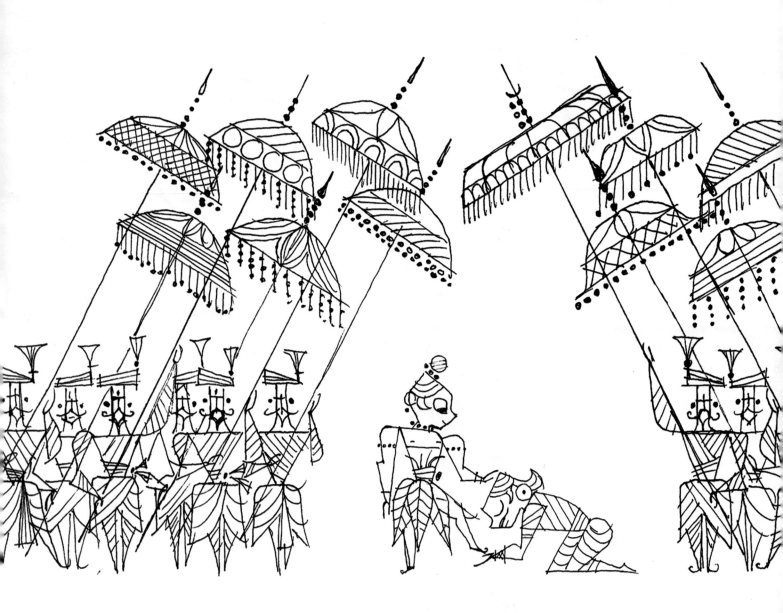

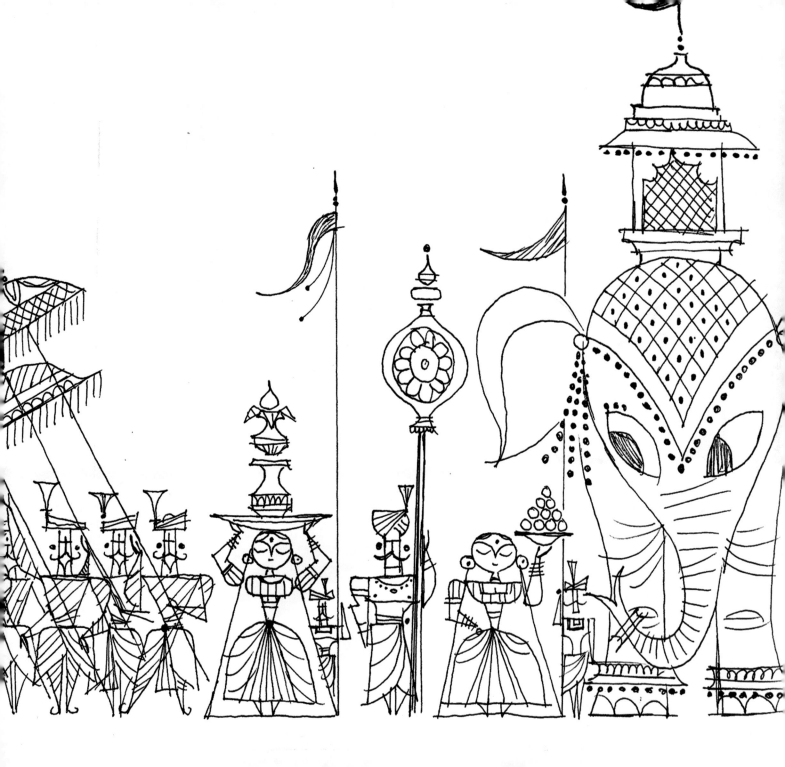

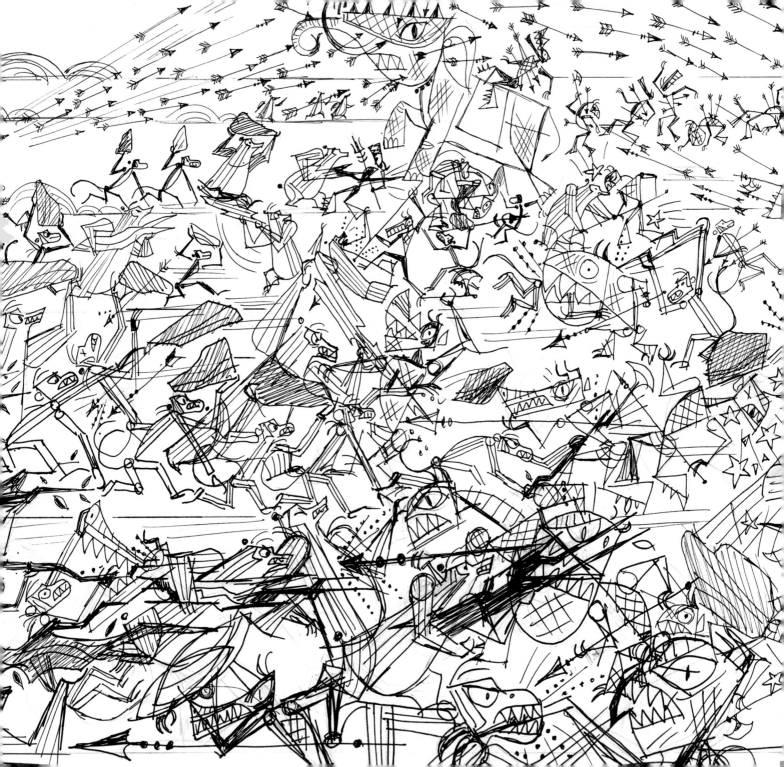

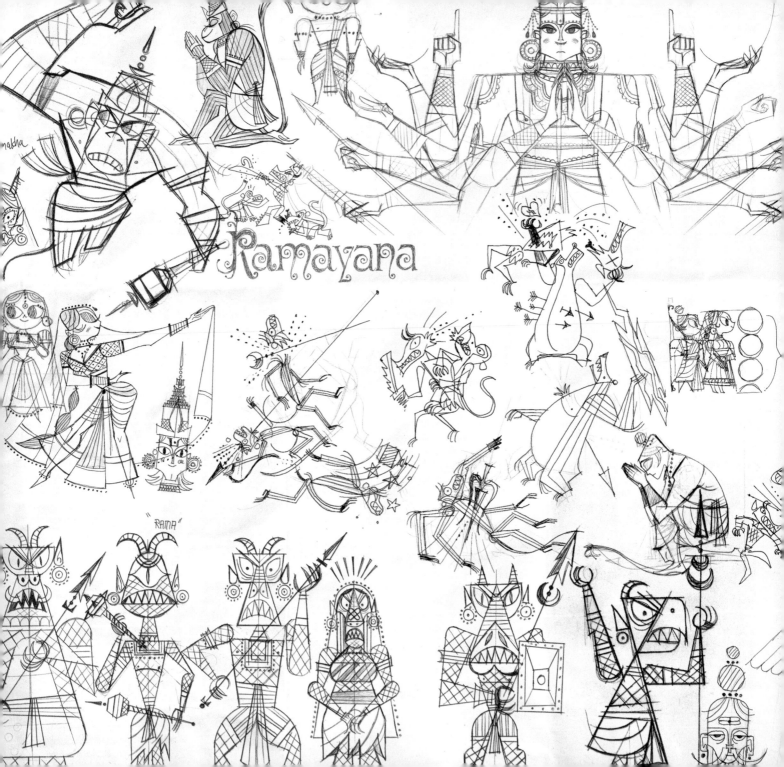

Ramayana

"RAMA"

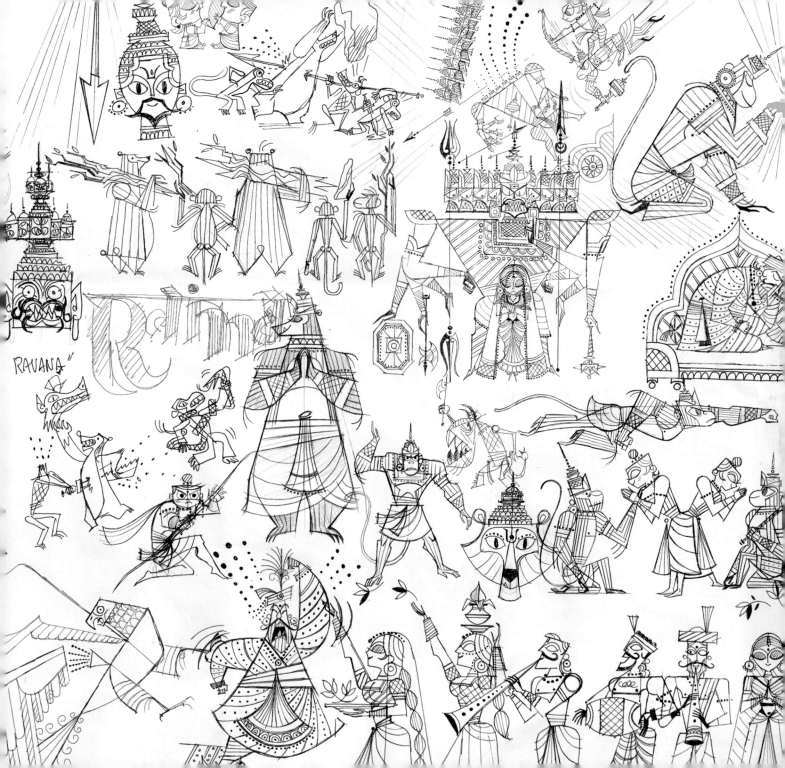

RAVANA"

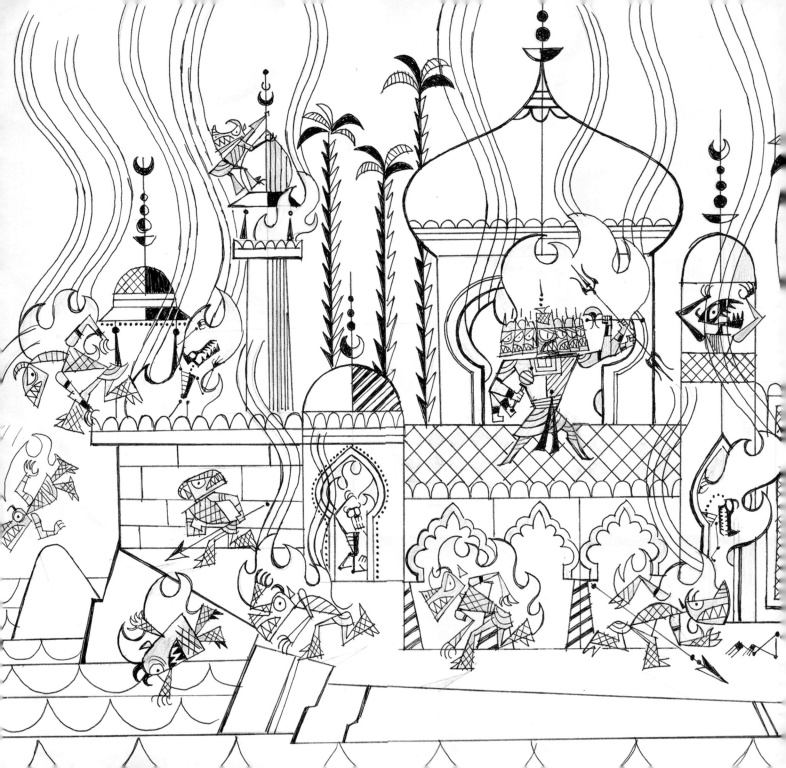

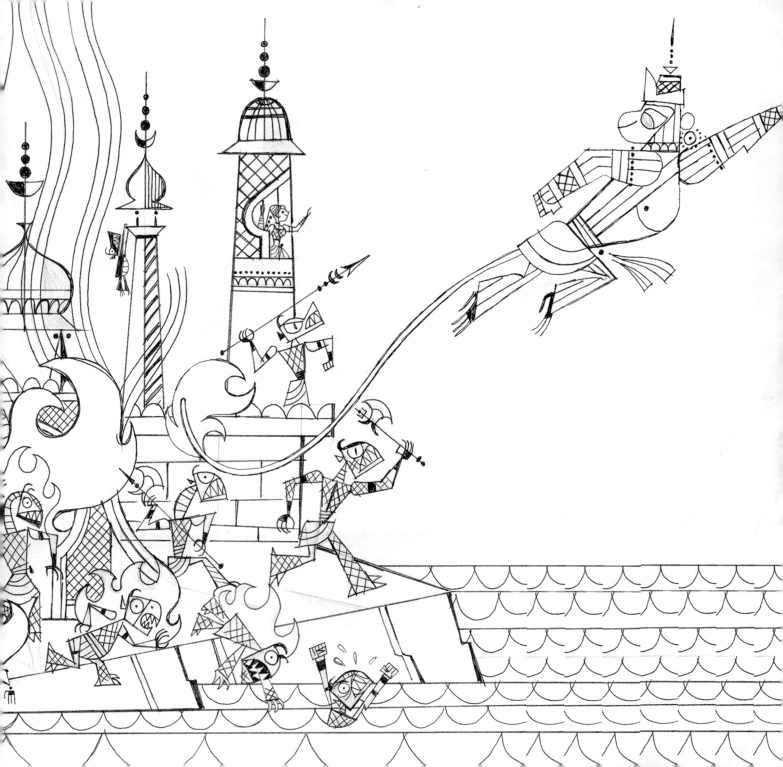

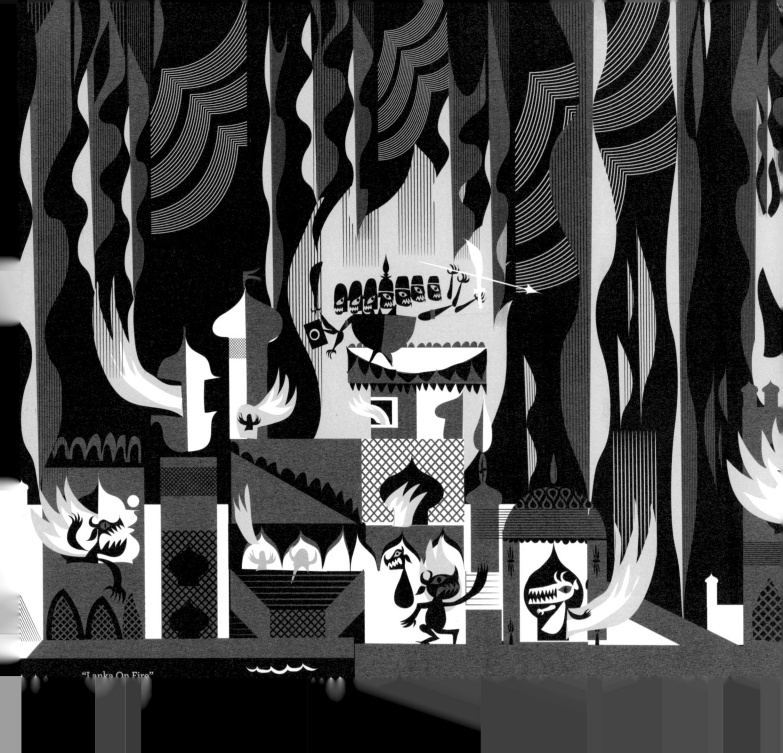

"Lanka On Fire"

ACKNOWLEDGMENTS

WRITING AND ILLUSTRATING this book has kept me isolated and confined to the vision in my head. For over four years when people asked what I did the night before or over the weekend, I told them the same thing over and over again: "I'm working on my book." And yet these same people stuck by my side, gave me support, and believed in my work.

I'm immensely grateful to the following people: Dad (**Gopal**), you instilled in me a work ethic that gave form and completion to this book. Mom (**Ramila**), the mystery of your mind led me to my art and my own inner world. Bro (**Amul**), your fearlessness and passion has always been an inspiration for me to keep pushing my boundaries. **Chiraag Bhakta**, a.k.a., *PARDONMYHINDI.com, a.k.a., Lifehere.com, a.k.a., Mr. Moustache, a.k.a., SheetRock, finding you has felt like I found the other half of myself; your good taste and sense of style is on every page of this book, as is your contribution and attention to all the design details that helped finish off this project. Your friendship, thinking, and vision has really opened my eyes towards creating a united voice for South Asian pop culture. **Emily S. Haynes**, your editorial stewardship helped me take this book to the finish line. When I needed a therapist, you were there; when I needed a critique, you gave it; when I needed a publisher, you made it happen; when I needed words, you lent me yours. I'm immensely grateful for your collaboration and commitment to my work. **Max Brace**, you've done more than anyone else in helping me adapt this epic story. You read the earliest version, then helped me tear the story down to the studs and rewrote the structure side-by-side with me. The behind the scenes folks at Chronicle, **Michael Morris**, for all the design, layout, and font feedback, **Beth Steiner, Emilie Sandoz, and Becca Cohen. Tina Duboise Wexler**, for always protecting my rights and being my legal bodyguard. **PIXAR**, for continuing to support me and independent projects like this book. **Tony Rosenast**, for sticking by my side 'til we reached the ancient caves of Ellora and Ajanta, to see one of the earliest incarnations of this same story. **Manisha Patel**, for sharing part of your journey with me and believing in my work. My entire **Gujurati family**, the West Coast cousins and their families who make so much room in their hearts for me, and the East Coast cousin who I miss. I know I didn't buy a motel, but I hope you're proud of this book.

Learn more about my work at **GheeHappy.com**

Aum shanti, shanti, shanti...
(Praise peace, peace, peace.)

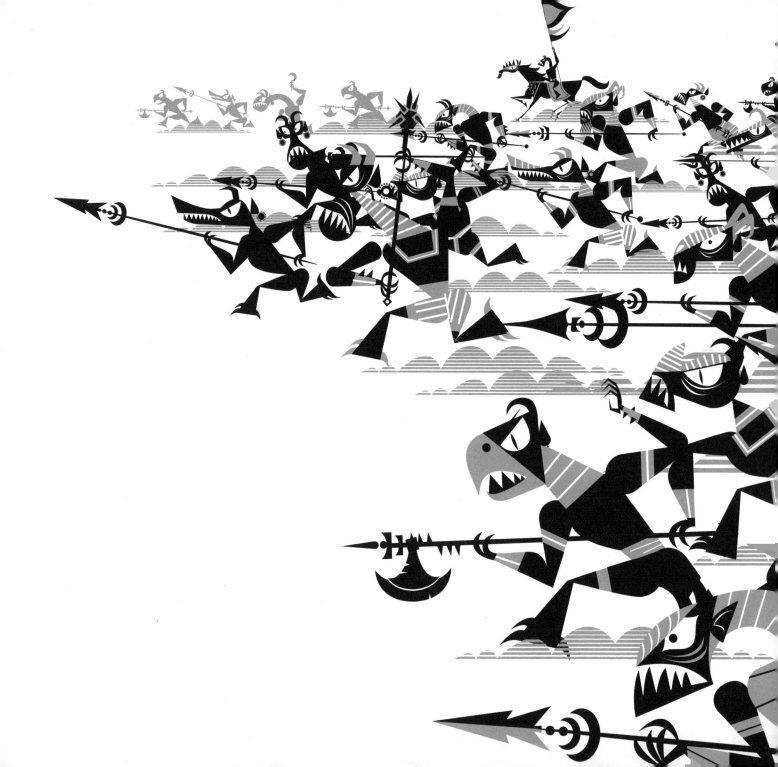